flower painting

through the seasons

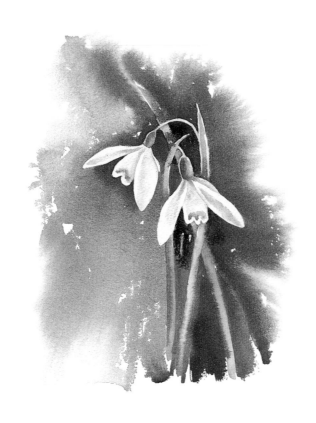

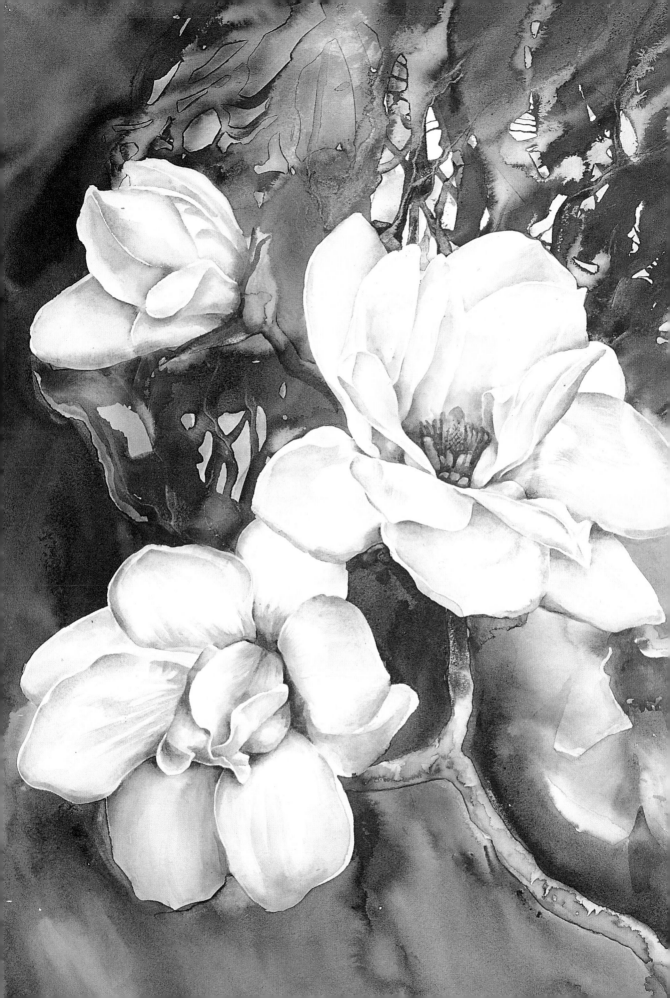

flower painting

through the seasons

PRACTICAL PROJECTS IN WATERCOLOUR

ANN BLOCKLEY

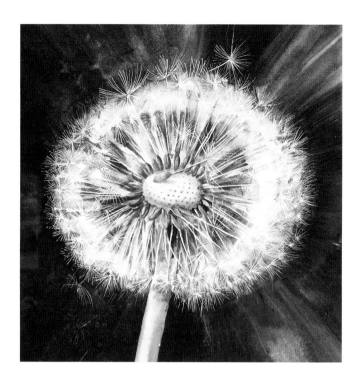

First published in 2001 by
Collins, an imprint of
HarperCollins*Publishers*
77-85 Fulham Palace Road
Hammersmith, London W6 8JB

This edition first published in paperback in 2004

The Collins website address is:
www.**collins**.co.uk

Collins is a registered trademark of
HarperCollins Publishers Limited.

05 07 08 06 04
2 4 6 5 3 1

A catalogue record for this book is available from the British Library

Editor: Diana Vowles
Designer: Ann Burnham

A companion video, also entitled *Flower Painting Through the Seasons,* is available from APV Films,
6 Alexandra Square, Chipping Norton, Oxfordshire OX7 5HL (tel: 01608 641798)

ISBN 0 00 715618 9

Colour reproduction by Colourscan, Singapore
Printed and bound by Rotolito Lombarda, Italy

Page 1: **Snowdrops** *26 x 20 cm (10 x 8 in)*
Page 2: **Magnolia** *53 x 42 cm (21 x 16½ in)*
This page: **Dandelion** *35 x 32 cm (13¾ x 12½ in)*

contents

introduction

The aim of *Flower Painting Through the Seasons* is to give you a subject that is interesting and sometimes challenging to paint throughout the whole year. The practical advice, visual ideas and projects are designed to help you not only learn technical skills but also to look at the world in fresh ways and thereby begin to develop your own personal painting style.

How to use this book

You may treat the book like a year-long painting course that can be repeated over again on different levels as your work progresses and new thoughts are stimulated. You can use it like a manual to a series of painting workshops with myself as tutor, or dip into it magazine-style for topical tips. Whenever you open it up you will be able to find an idea or problem dictated by the season; there should be no need for impatient armchair reading while you wait for flowers to bloom.

To give this year-round interest I have included not only the flowers but also other parts of the plants and stages of their life-cycle: the buds before the flowers open; the berries, fruit and seeds that emerge when the flowers have gone; the empty husks and seed cases that remain and finally the bare skeletons of stalks and stems. All of these varied subjects have their own individual and intriguing qualities. They all pose special problems and require different methods which are explored through a series of topics, projects and demonstrations.

▽ **Yellow Flags**
70 x 52 cm (27¹⁄₂ x 20¹⁄₂ in)
This painting (below left) uses the light hues and flowing wet washes of traditional watercolour that seem appropriate to the fresh new growth of early flowers.

▽ **Hollyhocks**
70 x 53 cm (27¹⁄₂ x 21 in)
These hollyhocks (below right) describe a typical summer scene with a complex arrangement of foliage and colourful blooms.

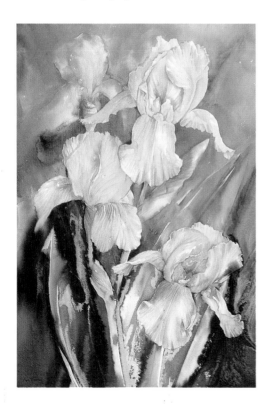

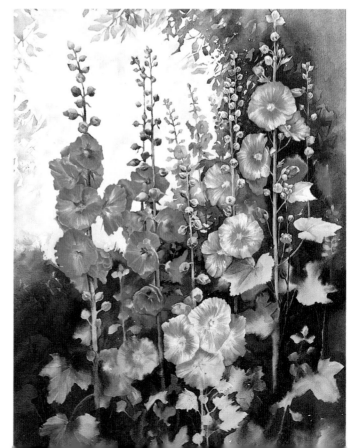

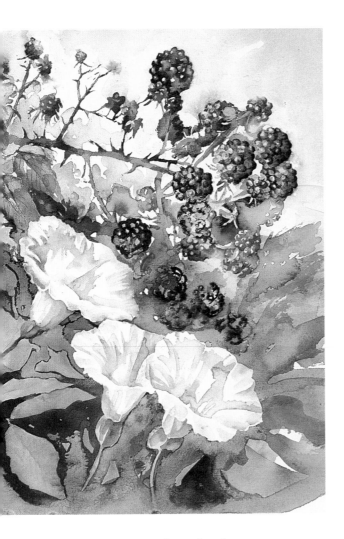

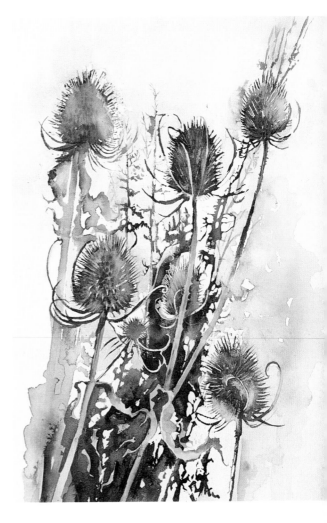

Monthly topics and projects

Each month has at least one main topic that covers a variety of styles, subjects, techniques and questions that are directly relevant to the time of year and sometimes also apply to other seasons. Every topic finishes with a project for you to tackle which relates to the preceding subject matter. These take the form of exercises that may be simple or more thought-provoking.

Step-by-step demonstrations conclude each month, covering popular seasonal subjects. They show you the methods used to plan and develop a painting from beginning to end. You may like to follow these closely to begin with, but in subsequent attempts you could repeat the process using different subjects and gradually introducing ideas of your own.

Further ideas are suggested that continue the themes introduced in the demonstrations. These aim to stimulate your imagination and start you thinking for yourself. As your confidence grows you will begin to create original interpretations and become more adventurous.

For easy reference, a glossary of techniques and a section on materials and equipment are provided at the back of the book to turn to for information on aspects of painting that are used throughout the seasons.

△ **Blackberry Patch**
33 x 25 cm (13 x 9³/₄ in)
The bramble patch (above left) is a typical autumn subject. The round, shiny globules of dark fruit contrast with the pale floral trumpets, while the network of thorny stems frames the twisting curls of bindweed.

△ **Teazels**
28 x 19 cm (11 x 7¹/₂ in)
The starkly beautiful shapes and patterns of seedheads and plant skeletons become more evident in winter. These teazels (above right) are tinged with subtle colours and their impact comes from the exploration of tonal values.

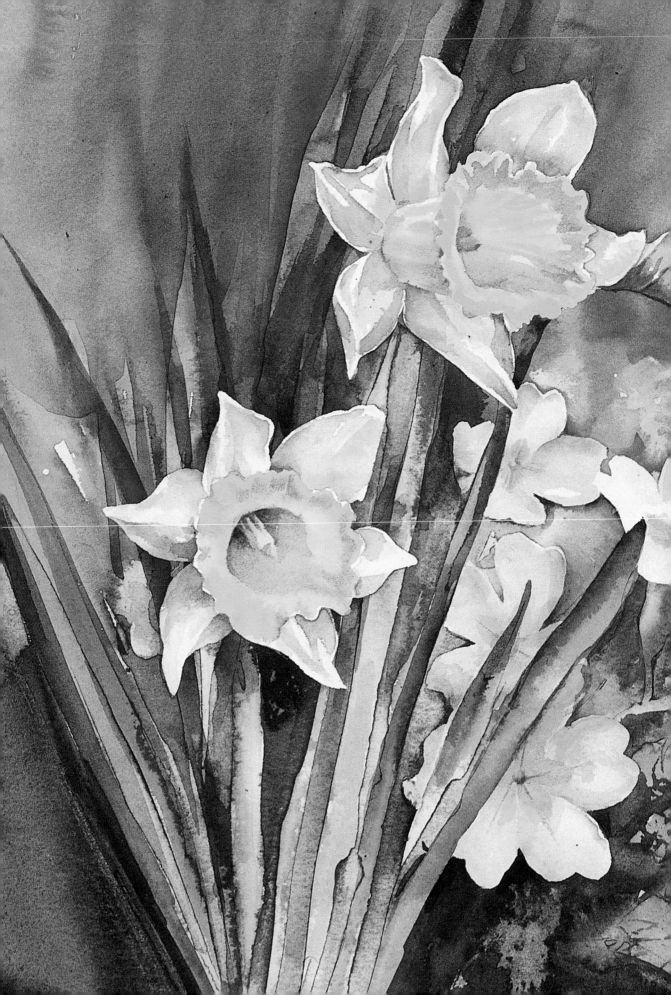

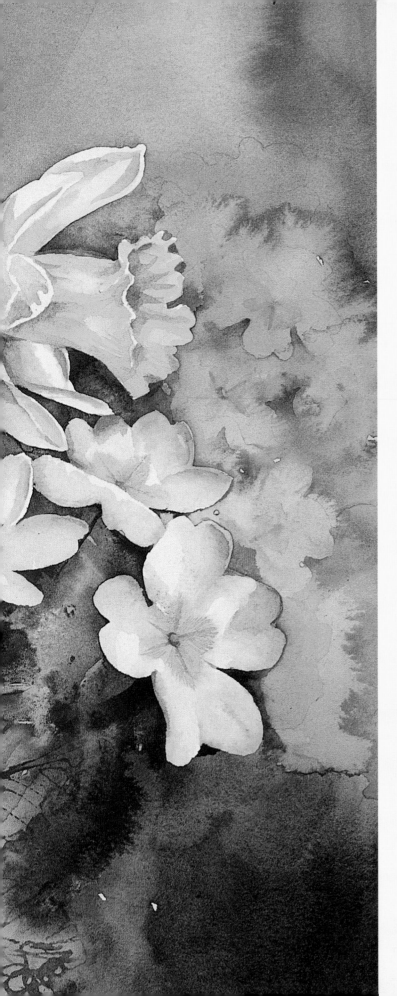

spring

Nature, the great conductor, leads the floral orchestra with its first tentative notes. Shy violets peep from shady corners. Catkins tremble from the willow. Primroses huddle under a hedge. Buds and shoots probe and test the air before they risk unfurling. Moody weather may lash out if flowers are precocious. The winds may rage and the rain cry. When the sun smiles, however, nothing can stop the ebullient fanfare of spring's arrival.

Spring Flourish
28 x 32 cm (11 x 12½ in)

march

In the garden violets peep from sheltered corners. By the river a wealth of kingcups glisters. Through the wood primroses smile at us, reflecting our pleasure. Amid the hedge, bare blackthorn branches blush with a froth of silky lace as if to clothe their naked bones. Brave blossom, young buds, bright flowers, new brushes; it is time to begin again.

Basic beginnings

March is the beginning of the floral year and is a time of renascence for the flower painter. This is a good month to get back to basics. Even experienced painters will be rewarded and refreshed by practising some traditional techniques. While the weather may still not encourage outdoor work, you should take the opportunity to start afresh and remind yourself of why you chose watercolour as your medium. Youthful flowers and leaves are best described with fresh unsullied washes of luminescent paint. The purity of watercolour is ideal for capturing raw, clean colours and delicate petals, the translucent paint allowing white paper to shine

▽ **Quince**

18.5 x 21 cm (7¼ x 8¼ in)
The stems of the quince dissect this picture in a sharp diagonal. Clouds of orange-coloured blossom in the top left and complementary blue shadows in the bottom right soften the geometry of the design.

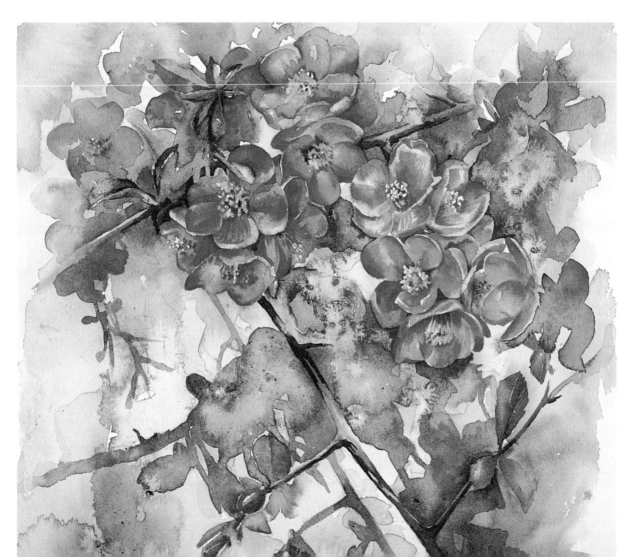

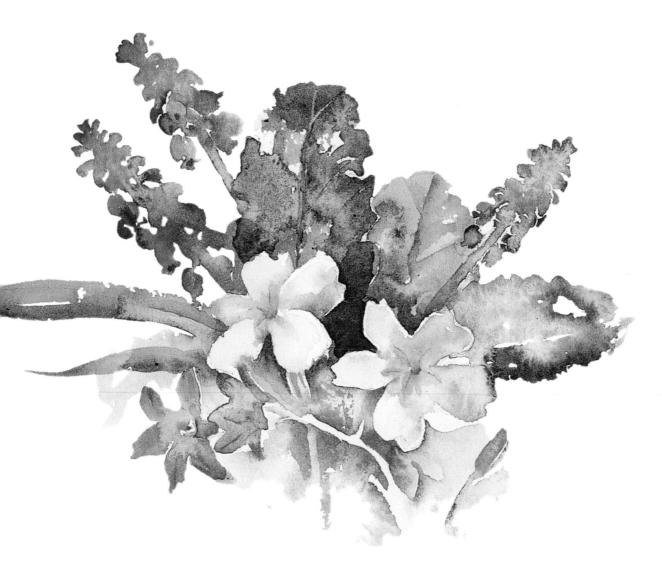

△ **Springtime**

14 x 19 cm (5¹⁄₂ x 7¹⁄₂ in)
All the elements of this simple
picture were built from a variety of
uncomplicated washes on a
miniature scale. The texture in the
leaves was made from water
dropped into a drying wash, while
the flowers were created either
from small variegated wet-into-wet
washes or graduated washes that
change tone within the petals.

through like light through a stained-glass window. You do need to be careful not to over-mix, however, as the petal freshness of watercolour can soon convert to mud.

The most important technique for the watercolourist to master is the wash. This can be a large expanse of background or a smaller area within the flower itself. It can be a single colour that can be varied in tone depending on the amount of water added, or a variegated mixture with one colour blending into another. You can try painting on either dry or wet paper, but remember to compensate for the fact that any moisture on the surface will further dilute the paint and it will subsequently be paler when dry. It is important to retain that bright spring colour.

Simple flower shapes

It is helpful that during this period of learning, the new flowers emerging are often simple and compact. Bulbs and native wild flowers are particularly abundant as they are hardy and their small, low-growing, sturdy frames are capable of tolerating the vagaries of March weather. Flamboyant flowers with complicated petals luxuriate in the kinder warmth that arises later in the year. The current easy flower shapes and pure colours are perfect for practising simple watercolour exercises, so pop some polyanthus in a pot and make a start.

Clean fresh washes

To keep washes pure and simple it is best to squeeze paint straight from the tube into a palette and dilute it with a brush. It is vital to mix plenty as you cannot interrupt the wash if you run out. The brush should be at least a size 12 and preferably a size 20 – too small a size may result in a fussy wash. Fill the hair with as much paint as it will contain without dripping and apply it to the paper, slightly overlapping each stroke and reloading as required. It is very important not to dab and blend as the damp marks should merge where they meet without needing further interference.

When varieties of colours are used within a wash the clearest, most vibrant combinations result if they are allowed to mix on the paper instead of in the palette. To achieve this, dilute each pigment first in separate palette compartments then let the different-coloured brushstrokes blend on the paper.

△ To keep colours bright but soft, watercolour should be diluted to a milky consistency. Excess water results in a pale wash, while too little prevents the paint from blending easily.

project . . . Developing flowers from a wash

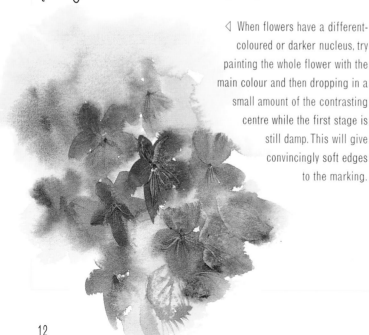

◁ When flowers have a different-coloured or darker nucleus, try painting the whole flower with the main colour and then dropping in a small amount of the contrasting centre while the first stage is still damp. This will give convincingly soft edges to the marking.

✦ Choose simple spring flowers and paint a background wash using some of the colours in the petals and leaves.

✦ While the wash is still damp, brush several flower and leaf shapes on top to create blurry background images.

✦ Paint in more flowers and foliage when the washes dry to give focal points. You can put in more details if you like, but spring flowers will be fresher if they are not overworked.

Complementary colours

When we think of spring flowers it is the piquant colour schemes we remember most sharply. Citrus yellows and violets almost sting in their clarity; grasshopper greens buzz against the cochineal red of tulips; and the chrome orange highlight on iris petals of electric blue is quite shocking in its intensity. It is as much the combination of hues as the individual tint that sings so loudly. Many of these are what are called complementary colours. This term refers to a combination of primary and secondary colours which includes all the three primaries. For example, blue (a primary colour) is complementary to orange (a secondary colour made from red and yellow, both of them primaries); yellow is complementary to purple (a secondary colour made from red and blue); and red is complementary to green (a secondary colour made from yellow and blue).

Complementary colours have the effect of intensifying each other, which explains why so many spring flowers and their leaves appear extra-bright. You can use this knowledge to give your paintings added zest.

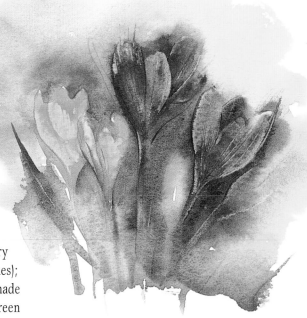

△ These contrasting crocuses were painted with Thioindigo Violet and Cadmium Yellow. The yellow in the golden flowers intensifies the plummy blooms. I added to this effect by placing another yellow in the background wash adjacent to the purple.

project . . . A spring posy

▷ I left the background white to let in air and light and keep the springtime freshness of this posy.

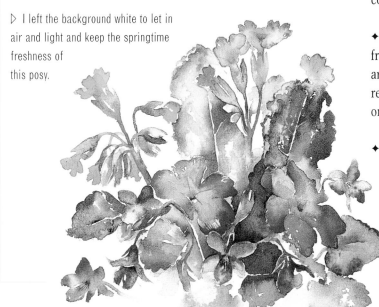

✦ Pick a variety of small flowers containing complementary colours.

✦ Put your finds into water to keep them fresh, but do not paint them as a stiff floral arrangement in a vase. Use them instead as a reference for composing a posy or vignette on paper.

✦ Aim for a busy design but be selective in which details to include. You might choose, for example, to leave out the hairs on the stems, the veins on each petal or the crinkles in every leaf.

Blossom and buds

For painting blossom, washes should be as pale and transparent as possible. Thin layers of dilute watercolour are more appropriate than single applications of thick paint. Work cautiously – you can always add but it is much more difficult to take away paint and retrieve that precious sparkle of clean paper.

Blossom is often white but if it is viewed against a light sky or another pale flower it will appear as a dark tone. When deciding how to paint these tones, the best approach is to try to see or even invent a colour in them such as blue or mauve, in the same way that painters find colour in shadows rather than thinking in terms of shades of grey. This will help to prevent the blossom looking dirty.

Pale flowers are best defined through the darker tone surrounding them rather than by using an outline for, of course, real-life objects are not enclosed by lines! The contrasting value could be a darker leaf, part of a bough, a blue sky or simply the shadow from another flower.

A quick, effective way to give buds roundness is to paint the whole shape in one wash then drip clean water into it when the edges are drying but the centre is still moist. This will shift the paint outwards, leaving the middle of the bud paler and gradually darkening to the edge.

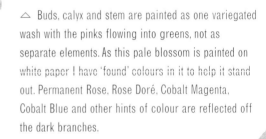

△ Buds, calyx and stem are painted as one variegated wash with the pinks flowing into greens, not as separate elements. As this pale blossom is painted on white paper I have 'found' colours in it to help it stand out. Permanent Rose, Rose Doré, Cobalt Magenta, Cobalt Blue and other hints of colour are reflected off the dark branches.

▷ Tender new leaves are often tinged with warm colours and in this sketch of quince blossom I have allowed the apricot reds of the buds and petals to mingle freely with the leafy greens.

project . . . Capturing the essence

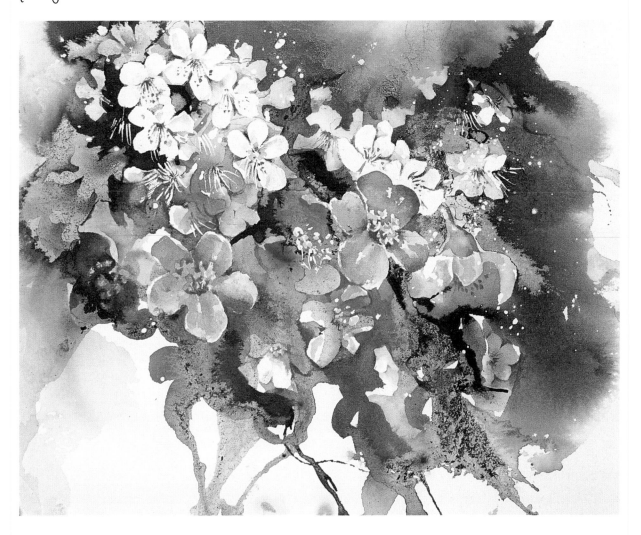

✦ A successful painting is one where the artist has a close empathy with the subject. Analyse what it is that particularly appeals to you in your subject and really emphasize those points to the viewer. Think in abstract terms such as shape, colour, texture and pattern.

✦ Choose colours that create atmosphere. Repeat the colours in the flowers elsewhere in the picture to stress their importance.

△ Pools of paint were blown upon and allowed to dribble in twiggy angles. Small, crisp marks suggesting petals were left within the washes. The foreground petals have enough detail in them for the imagination to give meaning to the bits only hinted at.

✦ Add detail to the focal points but do not turn every feature or abstract blotch into something specific.

✦ Do not always plan the design too rigidly. Rely on instinct and emotion instead of intellect.

demonstration . . . Primroses

After the long winter, primroses are one of the most joyful sights of the year. I tried to express my appreciation of this uncomplicated pleasure in a simple picture using modest colours of greens and yellow. Interest lies in the contrast between the wrinkled leaves and the smooth complexions of the flowers.

COLOURS

Aureolin
Cadmium Yellow
French Ultramarine
Green Gold
Hooker's Green Dark
Lemon Yellow
Warm Sepia

◁ **Stage 1**
My starting point was to draw the outlines of the primroses, spacing them so that some overlapped and others did not. One is in profile but most of the flowers are full frontal as I felt that this was the classic stance of the primrose gazing straight up from the hedge bottom. I filled the the flower shapes with masking fluid.

▷ **Stage 2**
After mixing several types of green in my palette from combinations of the chosen pigments, I brushed pale washes over and around the masked areas, allowing marks to happen that echoed or suggested the crinkly edges and surfaces of primrose leaves. I added granulation medium to some of the paint to help create more texture and splashed in extra water to make further ragged edges and runs.

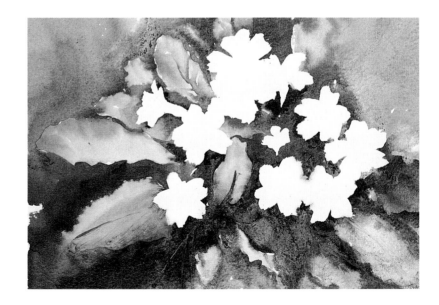

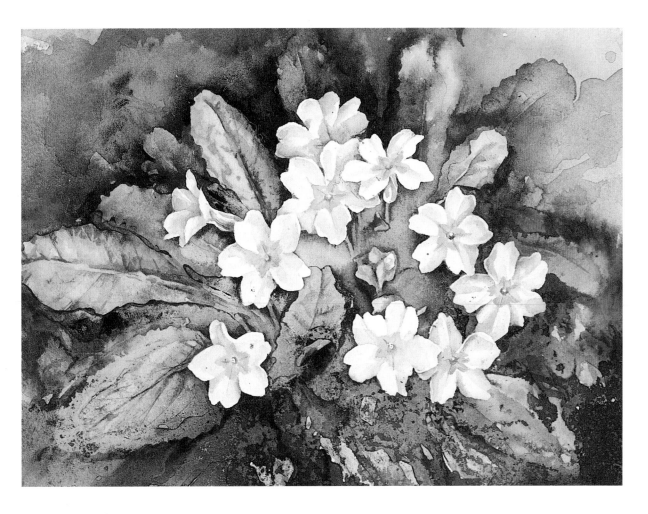

△ **Stage 3**

I painted another textured layer of wash, sharpening up some of the first leaves and adding some new ones to balance the design. I removed the masking fluid and drew veins into the foliage. The flowers were filled in with very pale washes of the two yellows and a little blue was used for shadow.

FURTHER IDEAS

The greens in the primroses above suggest a grassy bank or hedge bottom. Try to conjure a woodland feel now with neutral colours, peaty browns and fawns. Introduce another feature such as a few old oak leaves, a fern unfurling or other early woodland flowers such as violets.

△ Primroses *18.5 x 24.5 cm (7¹/₄ x 9¹/₂ in)*

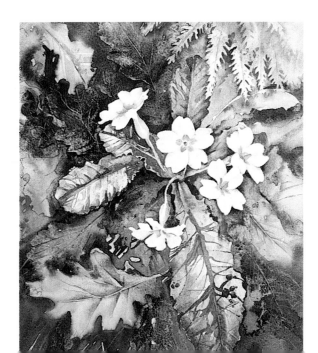

april

Spring is gathering momentum, and golden narcissi trumpets loudly exclaim the fact to whispering mauve honesty. The cuckoo-pint unfolds its mysterious hood, encouraged by the joyful call of its namesake. Dank corners are illuminated by dazzling daffodils. Showers follow sunshine. Chill winds quench warmth. It is a capricious month of contradictions and surprises.

A multitude of choice

Ever-increasing numbers of flowers open in a kaleidoscope of Easter-card brightness. Rhododendrons, camellias and magnolias remind me of glamorous ballroom ladies in sumptuous skirts of layered and flounced satin, while grape hyacinths stand soldier-like under the flirtatious flowering cherry.

 Above all it is the bulbs in April that fight for our attention, be they large or diminutive, bold and brassy or pale and delicate. They may be regimented in formal beds and bulb fields, saluting from pots on the windowsill or scattered in lavish abandon under woodland canopies. Even a single species of bulb can undergo

▽ **Rhododendrons**

25.5 x 33 cm (10 x 13 in)
The rhododendrons and their leaves create patterns of light and shade that are typical of this time of year. The large fans of plain, dark foliage are an excellent foil to the exotic flower formations.

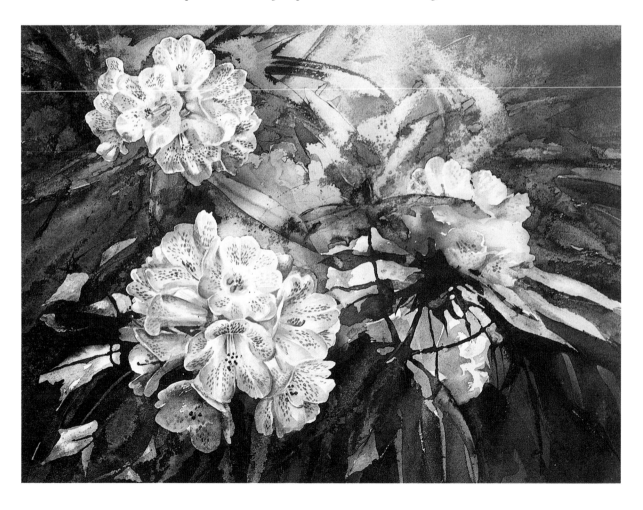

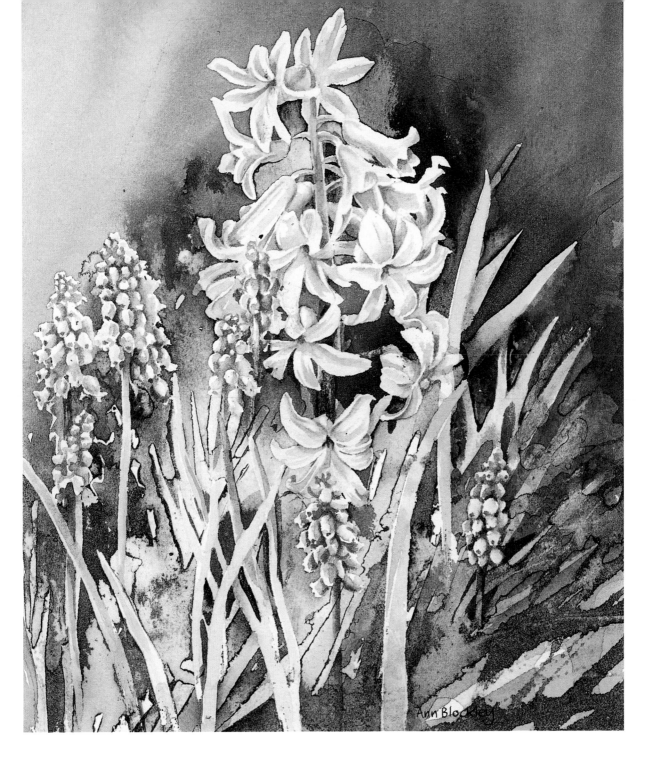

changes that could absorb a whole month of study. Tulips are a good example, being prim and proper one day but quite bohemian the next, sprawling lasciviously over lawn edges. They might be sprightly outside but loll and laze as soon as they reach a vase. As painters we have to think of ways in which to reflect these diverse personalities.

A solitary pillar-box red tulip could be painted with great detail in formal Dutch style on an inky dark background. Frilled flowers of fairground gaiety could be depicted in a decorative frivolous style with a merry-go-round selection of colour. Adapt your technique to capture the nature of the flower.

△ **Spring Hyacinths**
19 x 16.5 cm (7¹⁄₂ x 6¹⁄₂ in)
Spring bulbs are especially effective when grouped in masses of contrasting size, colour and shape. This is just as applicable when planning a painting as when planting your garden or window box.

Sketching spring bulbs

It is probably still too chilly to spend hours painting outdoors and watercolour is not compatible with April showers! Sketching is the obvious solution to recording the ever-increasing abundance of spring bulbs.

It is not just the value of a sketch as reference material that is important but also the time spent observing the subject while drawing. You are likely to absorb more information than is actually transferred onto paper as you are experiencing qualities such as movement, scent and change of light that will be stored in your memory and will add to the atmosphere of later works.

Because you work more quickly and it is 'only' a sketch, the result is often looser and less inhibited than in an 'important' finished painting. A really good sketch is highly selective – it hits straight to the heart of the issue and is not side-tracked by arbitrary details.

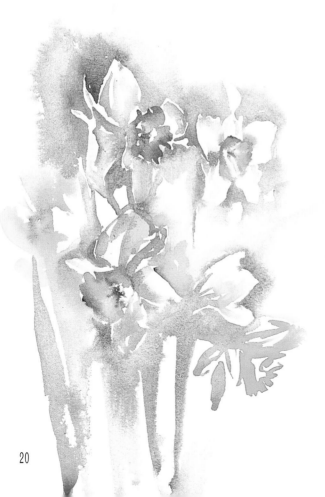

◁ I used the white of the background paper to describe light catching the edges of the narcissi. The sharp edges emphasize the zigzag patterns that the petals make.

project . . . Using a sketch as reference

✦ Choose a medium that reflects your main interest in the subject. Shapes might be described with pencil outlines, tonal values with charcoal or colour with a few bright inks.

✦ Concentrate on only one or two aspects of the flowers that fascinate you and make those a priority.

✦ Allow yourself a maximum of 10 minutes. This will prevent the temptation to sneak in extra detail. Impact is the aim.

✦ Take home some flowers and leaves if possible. Use both your sketch and the flowers to paint a finished picture, but try to keep the spontaneity of the sketch.

▽ **Woodland Daffodils** *36 x 25 cm (14 ¹/₄ x 9³/₄ in)*

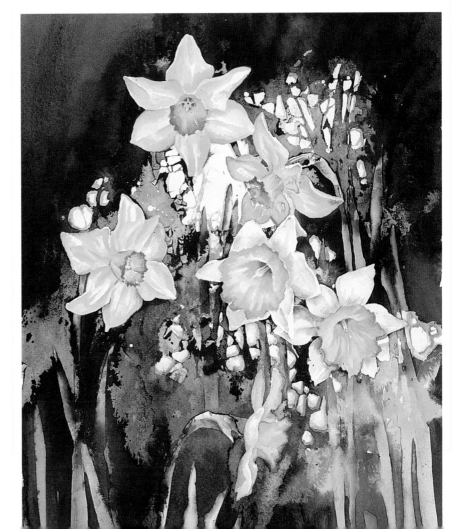

△ My main interests in this daffodil group were the golden yellows in bright relief against the dark tangle behind and the light pouring through gaps in the hedge.

spring

demonstration . . . Tulips

The raspberry ripple stripes and frilly edges of these flamboyant parrot tulips really appealed to me. I played with paint and water in order to create abstract marks that hinted at a profusion of blooms in the background without distracting attention from the foreground flowers. The process I used is reconstructed here.

COLOURS

Alizarin Crimson
Cadmium Yellow
Perylene Maroon
Phthalo Blue
Transparent Red Brown
Indian Yellow ink

▽ **Stage 1**

I drew the main tulips and leaves with pencil then painted around these shapes with a wash of Phthalo Blue and yellow ink, keeping the paint very wet where it would join the next area.

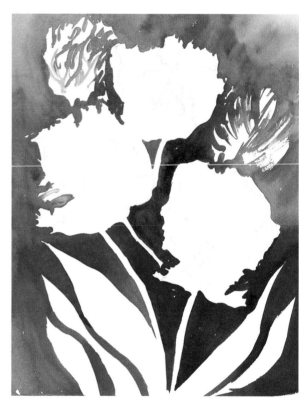

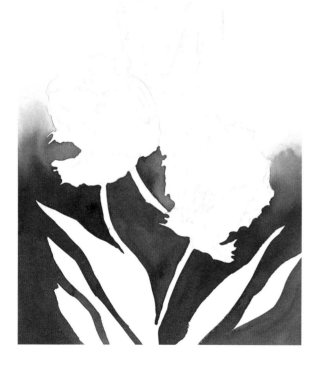

△ **Stage 2**

Next I washed in the top half, using combinations of the warm colours in my palette and letting the paint blend with the green lower half. White streaky patterns of paper were left where I would later include more tulips.

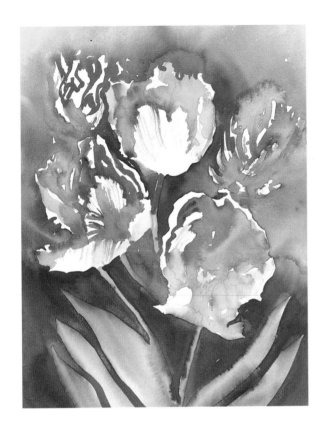

◁ Stage 3

I immediately painted in some of the flowers, again leaving white paper for markings or where petals curled. I allowed paint to flood into interesting runs to make pattern edges. Some parts were left hard but others blended in. I kept an eye on the green surrounding the leaves and before it dried I took a clean, wet brush and painted over the still-white foliage. A pale green wash was 'borrowed' from the surrounding area in order to give a pleasing combination of hard and soft edge values.

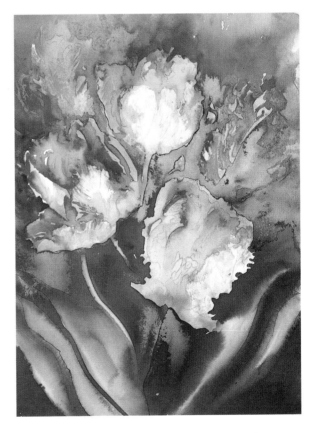

▷ Stage 4

The timing was crucial for this stage, where there had to be areas of both drying and damp paint. I dribbled clean water over the background and tulips, tilting the paper upside down to avoid disturbing the damp green area. Where the damp orangey colours washed out and edges smudged, the textures were suggestive of the petal markings.

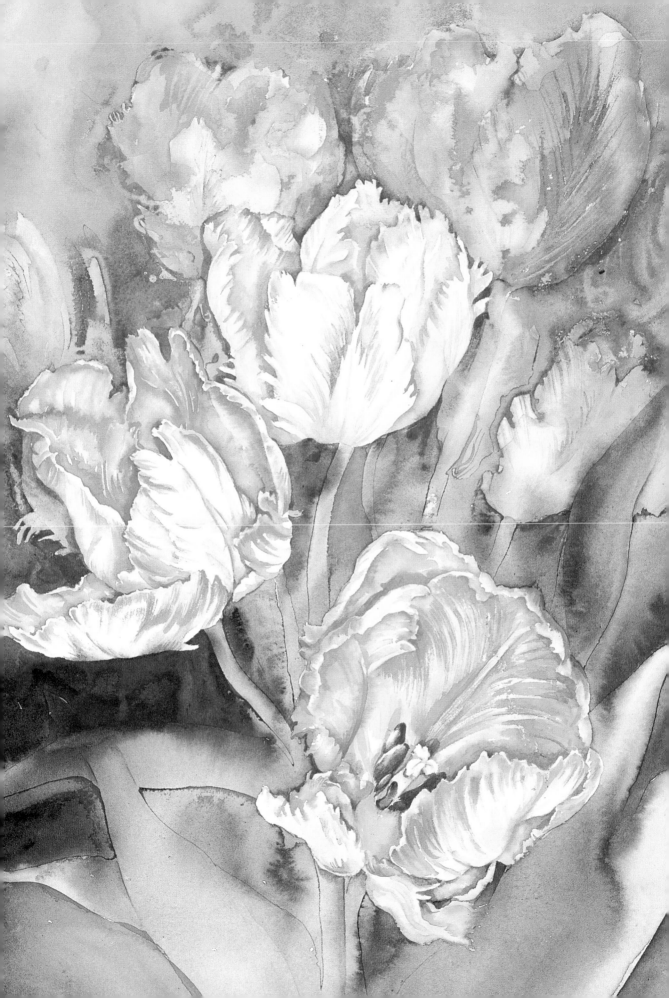

◁ Stage 5

I let the paint dry now so that I could add detail where needed. I put darker paint in the flower centres to emphasize their goblet shape and redefined the petals, dragging paint across to describe stripes and ridges. The variety of hard and soft abstract marks in the background were pulled into shape by adding to them or painting the background behind them.

◁ **Parrot Tulips**
38 x 28 cm (15 x 11 in)

Detail

The background marks you make will be difficult to predict and may vary considerably from this. It is the impression and suggestion they create rather than the specific texture that is important. Study what you have and what the edges suggest and make the most of them. They are a backdrop and not the focal point.

FURTHER IDEAS

Look at the outlines tulips develop when you bring them indoors. Their leaves and petals lose their pert formality and flop around lazily in the warmth. Stems twist and sway like sinuous snakes. Try designing a decorative picture that includes these serpentine elements. Remember to include interesting negative shapes and plenty of hard edges to help lend a graphic look.

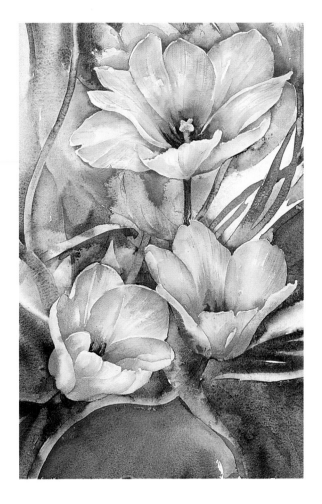

▷ **Tulip Time** *37 x 26 cm (14¹/₂ x 10¹/₄ in)*

may

May, month of bloom, bombards our senses with myriad maypole colours to dazzle the eye and fill the air with fragrance and buzzing honey bees. The hawthorn, Queen of May, is in bridal whites and cumulus clouds gather in azure skies to mimic the froth of blossom below. In meadows, wild flowers stitch intricate tapestries and in woodlands bluebells flood the world with indigo light.

Choosing a subject

In May, it is not a question of what to paint but which subject to choose. We no longer need to search for flowers to paint as there is such an abundance everywhere we look. The garden is full of endless variety from aquilegia to iris and peonies, while in the wild it is the sheer quantity of flowers that is breathtaking.

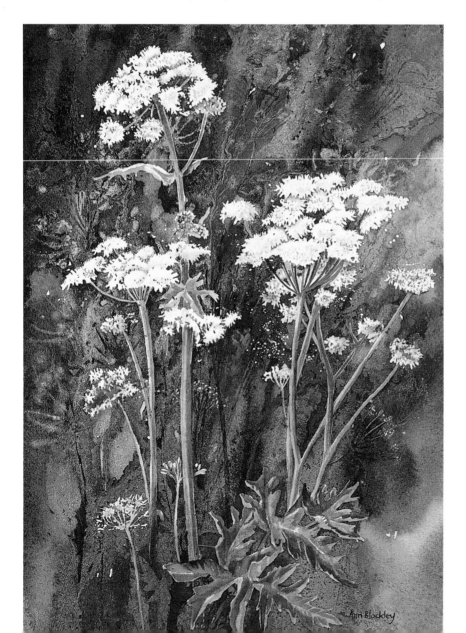

◁ **Hogweed at Twilight**
38 x 28 cm (15 x 11 in)
I am obsessed with cowparsley and hogweed and paint them repeatedly to try to project my renewed fascination with each fresh encounter. This version has a marbled background of blues and golds that re-creates some of the ambience of a hedge in May at twilight.

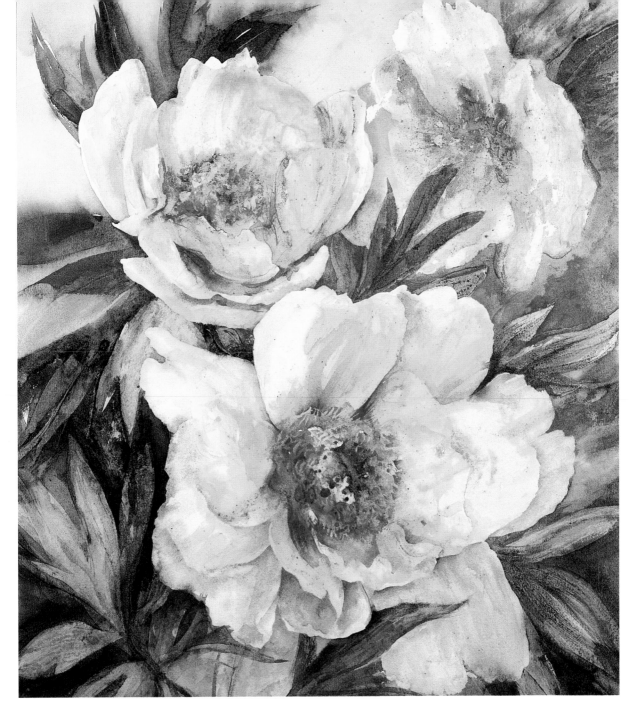

△ **Peonies**

72 x 56 cm (28¹/₄ x 22 in)
This painting is a very large
watercolour which concentrates on
the flowers alone, with just a few
leaves for contrast. This single-
minded emphasis on the peonies
allowed me to become deeply
involved in the textured centres
and sensitive colorations of
the petals.

Finding a personal style

To make your choice of subject, the key point is to follow your instincts and pick
what really excites and fascinates you. It may be colour, shape or pattern that fires
your imagination and it is your job as an artist to translate your delight onto paper.
You can explore different styles in a quest to discover the best method of expressing
your own feelings and observations.

Be inspired by other artists' work and emulate them by all means, but eventually
you should develop a style of your very own. As teenagers we experimented with
various signatures until one day we discovered that our handwriting had naturally
developed without our even realizing it. This is what will happen as you become a
more experienced painter and your pictures will reflect something of yourself.

Using masking fluid

I use masking fluid widely in my work, usually if I am protecting a feature from a messy background. The foreground subject will usually remain prominent because of the resulting harder edge values. Masking fluid is very valuable to a painter but its use is the area my students seem to have most difficulty with. However, as long as you observe the following rules you should not experience problems.

First, check that your paper is suitable before starting as some papers tear on removal of the masking fluid. The masking fluid should be allowed to dry thoroughly before paint is applied and the paint must be absolutely dry before the mask is taken off.

When you are masking a solid shape it is vital to paint the edges accurately and fill in the whole area without any gaps. The dry masked shape can then be painted right over; painting carefully around it negates its use completely.

You can paint masking fluid on top of a dry wash but it may lift off some of the colour, leaving a paler shade. Masking fluid should not be diluted, and its application must be considered carefully first; it is a mistake to dot masked features indiscriminately throughout the picture.

▽ **Dandelion Clock** *13 x 14 cm (5 x 5½ in)*

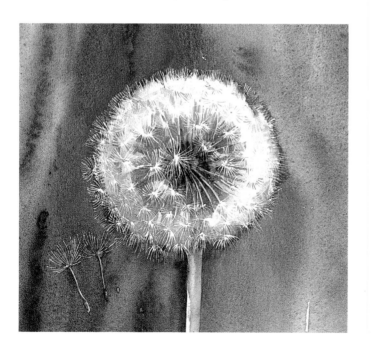

✦ Try out different ways of painting wild flowers using masking fluid. The aim is to create uninhibited wet-into-wet or textured washes behind a shape which is too complex to paint around.

✦ Use a pen nib for very fine lines such as dandelion clocks, seeds or stamens.

✦ A shaper is useful for the very small, fiddly flowers of cow parsley, for example, but be careful when using shapers on larger areas as streaky paint will seep through if the masking fluid is not solid enough.

✦ Mask big areas and solid shapes like daisies and buttercups with a brush.

✦ Try flicking dots of masking fluid with a palette knife or old toothbrush to add sparkle and texture.

✦ Paint coloured flowers too. White ones have been chosen here only because they show the technique most clearly.

✦ To help the flowers sit comfortably in the picture after removing the masking fluid you can either soften some of the edges or use tones and colours in places to match the surrounding background.

◁ Stage One

The solid daisies were filled in with a block of masking fluid, treating the overlapping flowers as one shape and including the daisies' 'eyes'. When the mask was dry washes and marks were painted into the background, working right over the daisy shapes. I peeled away the masking fluid when it was bone dry.

▷ Stage Two

Crisp edges within the background wash echo the hard-edge masked shapes and start to balance this unfinished picture. Some of the petals are darker than the surround and some paler to help settle the flowers in.

◁ The left-hand side of this painting of hogweed is completed but the right-hand side remains at the stage where I pulled off the masking fluid. The lacy texture is where I rubbed the dry masking fluid to tear tiny holes and allow dots of paint to reach the paper.

Creating a focal point

A flower study needs a focal point – something important that attracts the eye instantly. The picture might contain other interesting ideas for the eye to explore, but the main attraction should always draw the viewer back again like a magnet. This holds true for any painting style, whether traditional, abstract, loose or detailed; certain marks, colours or shapes should be more important than others.

There are many ways for you to create a focal point. Placing is one of them. Let us assume the main feature is a particular clematis flower. Putting the main clematis in a prominent place, not at the edges but at centre stage or at the top of the design, will help. It could also be larger and more detailed than other smaller, more loosely painted versions around it. If you use masking fluid to start with, this flower will be crisp and contrasty, directing the gaze more than a blurred wet-into-wet interpretation. Let the 'eye' or centre of the flower face your gaze. Flower profiles, just as in portraits of people, can be less imposing.

▽ **Clematis**

28 x 35 cm (11 x 13³⁄₄ in)

Stems lead the viewer into this painting. The leaves also angle in the direction of the focal point, training the eye towards the main clematis flower. Arrangements like this that are offset and counterbalanced can be more eyecatching than symmetrical layouts. Vary the distance between the flowers, with some overlapping and others spaced apart.

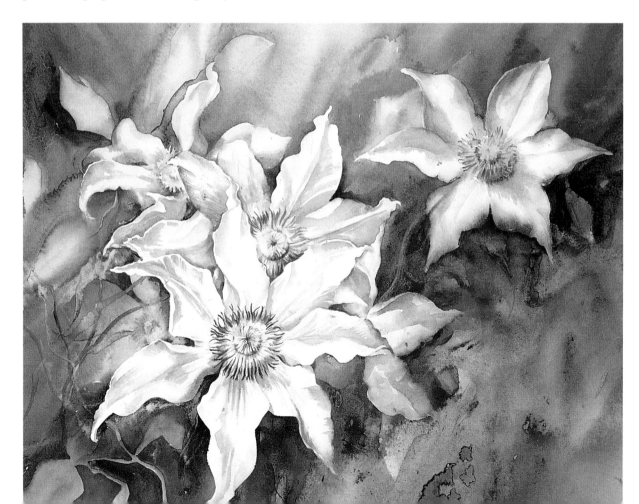

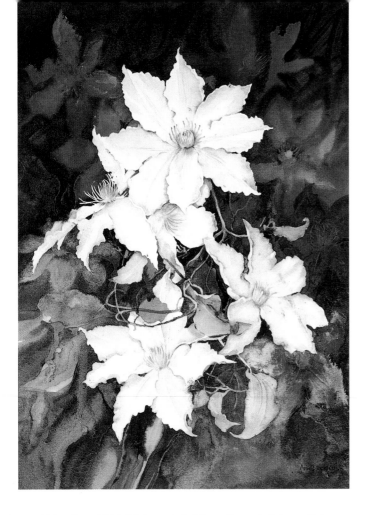

◁ **White Clematis**

33 x 22.5 cm (13 x 8³/₄ in)

Here the flowers are placed at a variety of angles to keep the eye interested; an odd number of flowers and leaves seems easier to arrange in a pleasing pattern than an even number. We tend to be attracted first to those flowers which face us most directly. Strong tonal contrasts between the background and the clematis train the eye on the flowers.

project . . . Arranging a small floral group

✦ Take a flower species and choose three examples to include in a picture. They might vary in size, colour, pattern or stage of growth.

✦ Cut your paper to a shape and size that reflects that of the flowers; tall and thin for foxgloves, horizontal for spreading plants or a tiny piece for small geraniums.

✦ Compose the three flowers in a pleasing design. The petal shapes could be reflected in the composition. Pansies, for example, with their rounded petals could be placed in a circular group, while pointed clematis stars might be positioned in an angular zigzag.

✦ Use other neighbouring flowers and leaves for background colour or distant versions to link with the foreground.

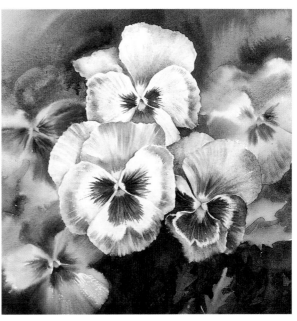

△ **Pansies** *36 x 34 cm (14¹/₄ x 13¹/₂ in)*

31

spring

Carpets of flowers

In May it is the sheer abundance of flowers that makes us gasp with pleasure. When flowers bloom in small groups we are grateful to see them, but a snack, although satisfying, cannot compete with a feast. Now we have not just single peonies but flowerbeds full. Clusters of buttercups have multiplied into whole meadows, and woods are carpeted with bluebells.

When flowers grow en masse they lose their individual shapes. They become more abstract, and detail is pared down to the essential. A hedgerow of wild garlic becomes a lacy texture, the essence of dandelions in a field is captured by dots of gold and a swathe of bluebells is an unadulterated blur of intense colour.

▽ The simplest washes of colour and flecks of detail are enough to create the effect of a carpet of wildflowers. The flowers are represented by a general approximation of marks, some splattered with a toothbrush, others dabbed on with a brush. This might be a buttercup meadow or a field of rape. I have chosen not to spell this out.

project . . . Painting a bluebell wood

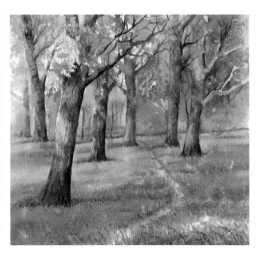

△ **Bluebell Wood** *25 x 29 cm (9³⁄₄ x 11¹⁄₂ in)*

✦ Use a variety of blues for the flowers such as Cobalt Blue, French Ultramarine or Phthalo Blue. Mix with touches of pink to give warmer shades of blue.

✦ Paint with graded, variegated washes, keeping colour stronger in the foreground.

✦ Use horizontal brushstrokes to place darker wet-into-wet stripes where the late-afternoon sun casts rippling shadows.

✦ Dot texture into the damp foreground, roughly suggesting the structure of the arching bluebells. Try using a water-soluble coloured pencil or crayons.

Depth and distance

When you paint a mass of flowers viewed from afar it is relatively simple to imply distance by gradually reducing tone, texture and colour. If you are looking at your subject from a closer vantage point, while still with plentiful flowers behind, there are other points to consider.

Objects appear to diminish as they recede, making foreground objects look bigger. Colours appear cooler the further away they are, which means, conversely, that warm colours tend to come forward. The same principle applies to tonal values and colour intensity. Strong colours leap out and weaker washes retreat. If the flowers at the back blur as they fade out of focus this will also lend depth to a painting.

▽ The foreground daisies were blocked out with masking fluid to give prominent, crisp edges. The effect was loosened by splattering on more masking fluid with a toothbrush. Washes of colour indicate distant flowers. The combination of dark foreground under the daisies and the pale trees beyond enhances the sense of depth and distance.

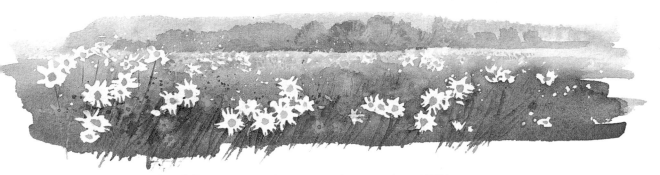

project . . . A wildflower meadow

✦ Paint yourself a wildflower meadow. You can use a variety of flowers, but limit yourself to three types. Wild flowers in bloom in May include buttercups, daisies, wild garlic, cowslips, dandelions, red campion, meadowsweet and ragged robin.

✦ Give depth using the guidelines above. To summarize, as the flowers recede make them progressively smaller, less detailed, cooler, paler and softer.

✦ Dab dots of wet colour into damp washes to create distant background flowers. Paint crisp foreground detail when the paper is dry.

▷ **Meadow Flowers** *17.5 x 14 cm (7 x 5¹/₂ in)*

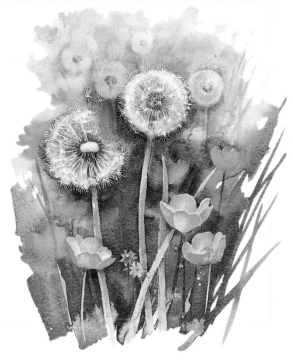

demonstration . . . Irises

In my work I often paint backgrounds first, although artists who are unsure of their skills tend to prefer to start their painting with the flowers instead. In this picture I demonstrate a way of introducing some colour and foliage behind the flowers without radically reversing the latter approach.

COLOURS

Burnt Umber
French Ultramarine
Gamboge
Purple Madder
Ultramarine Violet
Yellow Ochre

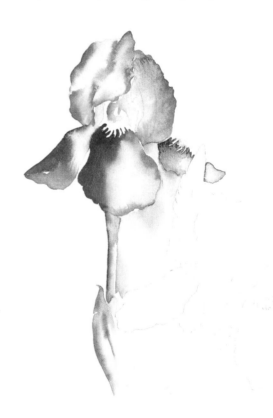

▽ **Stage 2**
The initial painting was done with mixes of French Ultramarine, Ultramarine Violet and Purple Madder, shading with plenty of water.

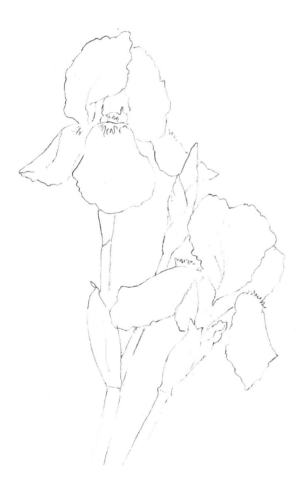

△ **Stage 1**
First I drew the outlines and some of the detail of the flowers, using a B pencil and taking care not press too hard on the paper.

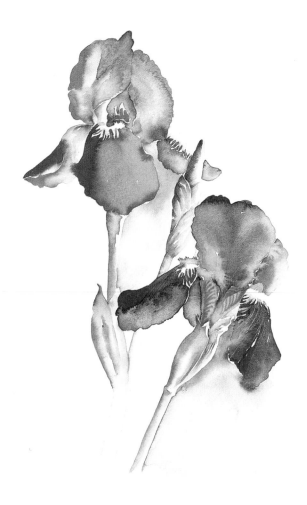

◁ Stage 3

The process was continued using similar colours and the same loose style, with the background incorporated as I went along. Sometimes this was dark against a pale stem or a light wash to border a dark area. Where two damp places met a soft edge resulted, helping to link the flowers with the background.

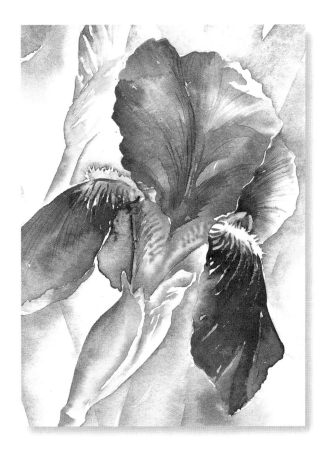

Detail

It can be daunting to begin incorporating background details onto white paper when your flowers are at an advanced stage. A method I often use to help with this sort of decision-making is to draw the foliage on tracing paper and juggle with different compositions. I also experiment with tones and colours on scraps of paper, holding them against the picture to ensure that the new elements will harmonize with the flowers. This detail shows some of the shades of green I used for the stems. I included French Ultramarine and Yellow Ochre and occasional hints of Purple Madder or Burnt Umber in the warmer areas.

spring

▷ **Stage 4**

The blade-like leaves were painted with very simple flat washes. I introduced Gamboge to the green already used to make a slightly different version that would contrast with the foreground colours. Where leaves overlapped I left them as one shape and refrained from putting in any detail so as to focus attention on the flowers.

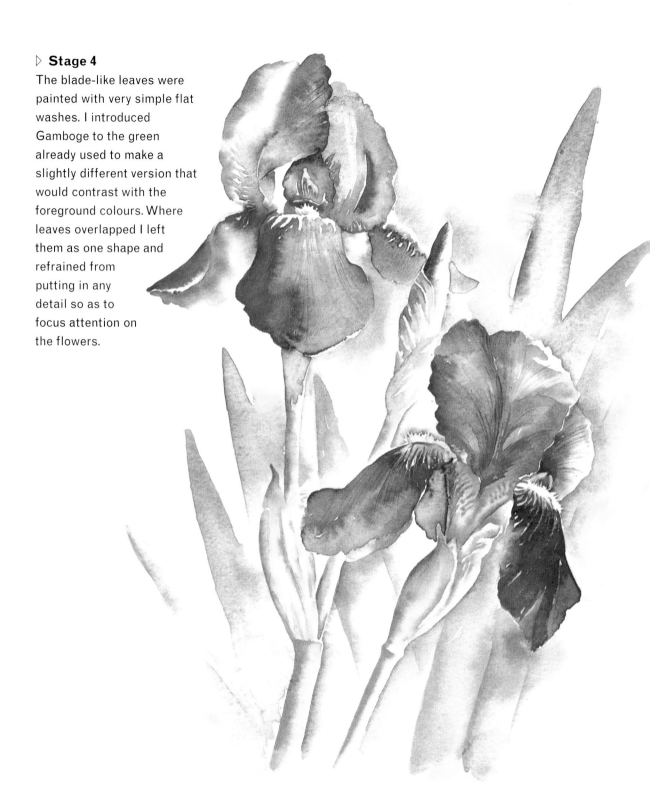

△ **Irises** *30 x 24 cm (11³⁄₄ x 9¹⁄₂ in)*

FURTHER IDEAS

Take a favourite flower and paint it over and over again. Being obsessive is a good trait for an artist, as it is important to be absorbed in your subject. Think of Van Gogh's sunflowers or Monet's water lilies; both artists were engrossed in their chosen themes. Each time you paint your subject, study a different aspect so that the range of paintings makes a series of statements. Iris shapes might suggest a decorative Art Nouveau style, for example, or you might concentrate on the graphic fans of flat leaves. Alternatively you might become involved in the texture of the petals and their frilly decorations.

▽ **Peach Iris** *66 x 51 cm (26 x 20 in)*

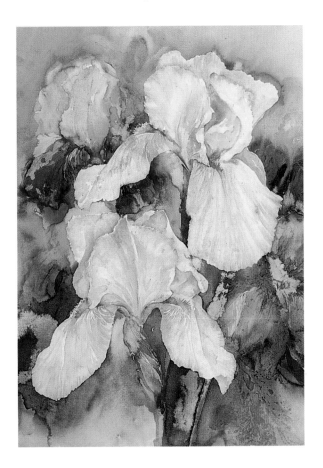

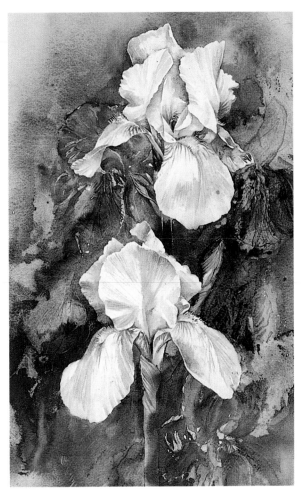

△ **Blue Iris** *42 x 20 cm (16¹⁄₂ x 8 in)*

The paintings shown here demonstrate my fascination with the many different colour schemes the iris offers. The two pictures are similar in many ways. One is stretched into a longer format but otherwise the juxtaposition of the two flowers is the same. The flower heads are viewed from similar angles and the focus of both works is on these, with softer versions behind. What makes the two paintings radically different is their size and choice of colour: one is large, rich and warm with peaches, purples and yellows, while the other is smaller and a cooler combination of blues.

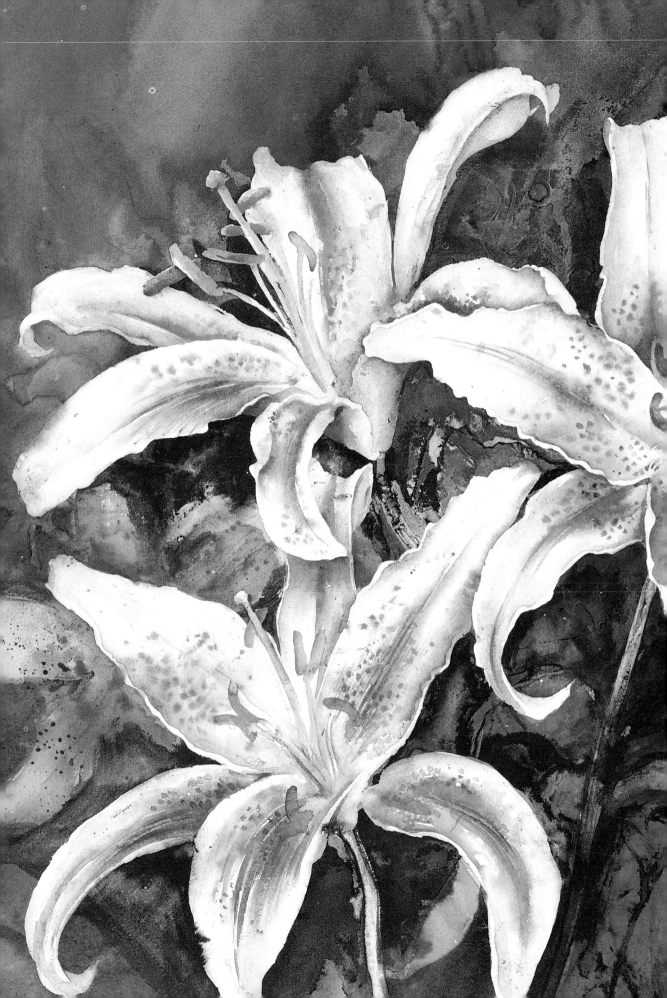

summer

june july august

The summer garden is a living merry-go-round of colour and pattern; dots, spots, stripes and swirls. A thousand flowers jostle for space, seeking the attention of the painter. Poppies flirt and flutter their eyelashes, roses simper, hollyhocks pose and foxgloves sulk in the shade. All compete for the fame and immortality that an artist can bestow by capturing and pinning ephemeral petals to paper like diaphanous butterfly wings.

Stargazer Lilies
51 x 65 cm (20 x 25½ in)

june

Flowers without number weave sweet disorder through warm enchanted gardens. Luxuriant bright blooms thickly adorn the painted borders. Delicate stars and dappled bells mingle with the voluptuous curves of peonies, while swathes of scented eglantine cast spells of midsummer magic. June brings a dazzling array of subjects for the flower painter.

Cottage-garden flowers

In June we are seduced by the pastel colours and hotchpotch variety of the cottage garden. This riot of flowers is a real challenge. When a range of colours, shapes and patterns occur within the painting we have to plan elements of structure to tame a potential jungle of paint marks. We can, for example, offset busy areas of a picture with empty spaces, juxtapose rich colours with subtle ones, contrast large flowers with small, or combine a complicated mass of florets with a couple of simpler shapes.

We should be aware of the importance of leaves, their shapes, colours and structure. It is a temptation to concentrate on painting flowers and treat the leaves as an arbitrary afterthought; something useful to fill up a space. Instead, they should be planned in at the beginning as an intrinsic part of the design, even if they are only destined to be loose impressions. Make sure also that they are in proportion - a common mistake is to paint leaves far too small.

▽ **White Peonies**

28 x 40.5 cm (11 x 16 in)
In June white flowers such as these peonies show up brightly in the garden long into the warm dusk evenings. To retain their clarity in watercolours it is best to use the white of the paper rather than gouache. The flowers should be clean, with a minimum amount of shadow. It is important to avoid overworking them.

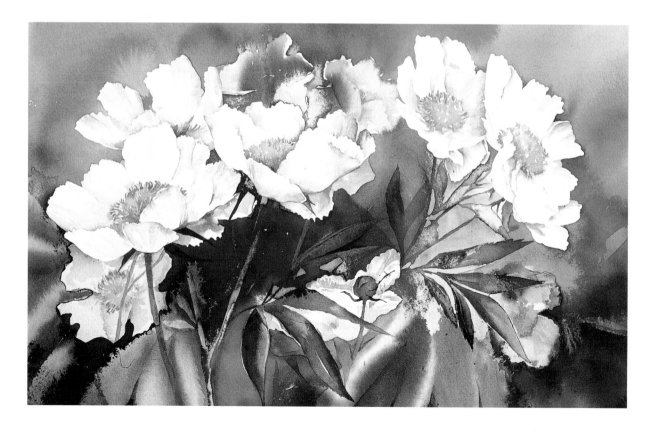

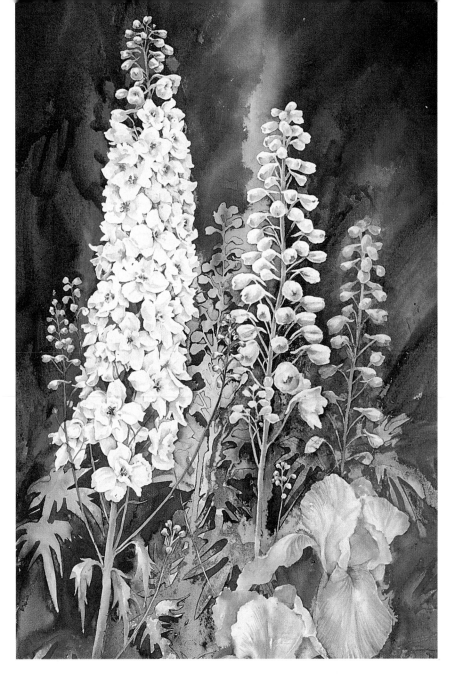

◁ **Summer Garden** (detail)
Background colours do not have to
be green – they can be any colour
you want. The colours may be
suggested by a patch of flowers
behind or by some rich foliage on
a distant tree.

Planning ahead

In some years all my favourite flowers come into bloom simultaneously; roses,
delphiniums, hollyhocks, sweet peas and peonies are all jostling for attention.
Sometimes I combine several species in one picture but that still leaves an awful
lot of opportunities and I want to paint them all. Unfortunately, there is never
enough time to achieve this before they wither. So, just as we fill up our freezers
with a glut of edible produce for when the pickings are thin, flower painters must
record for later those ideas that cannot be painted then and there.

Make pencil drawings and take photographs. Do watercolour sketches of colour
combinations. Make notes on how light falls on a petal or how it is shaded and fill
a notebook with outlines of different leaf shapes - perhaps even press a few. If you
make a habit of thinking ahead and recording information, you will always have
plenty of subjects to paint.

Interpreting a subject

Certain floral themes are so attractive and so classic that they are repeatedly painted and have become clichés. However, this does not mean that they have lost their charm. On the contrary, we still love them. The problem is how to avoid stereotyped, hackneyed images when painting them.

Roses

Look at a rose bush and imagine that it is an alien object you are seeing for the first time. You should view it in terms of pure colour, shapes, tonal values, negative spaces, sharp and soft areas and so forth. By balancing these different elements in your composition you will avoid sentimentality and make an original statement. It may help you when you are deciding how to paint your chosen flower to think in terms of the following styles: romantic – pastel colours, wet-into-wet washes, hazy flower impressions, rounded shapes; traditional – detail, realism, a busy but balanced composition, middle-range colours; graphic – crisp edges, flat shapes, texture, simplicity, tonal contrasts; and decorative – unrealistic colours, pattern, fantasy.

△ **Dog Rose**
25 x 17 cm (9³⁄₄ x 6³⁄₄ in)
This graphic image has a strong emblematic quality. The simple clear-cut shapes stand out against a dark background subtly textured with a range of ochres, olive and blue greens.

◁ **Pink Roses**
25 x 46 cm (9³⁄₄ x 18 in)
This is an interpretation of a very traditional English rose which avoids sentimentality with its balance of values. Flowers and leaves are silhouetted against paler ones and dark foliage offsets a pale sky. The wide, horizontal format helps create an atmosphere of peace and relaxation.

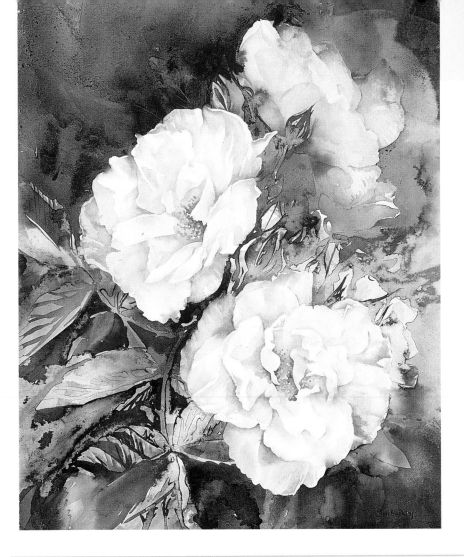

◁ **White Roses**
56 x 44 cm (22 x 17½ in)
This is a highly romantic vision of white floribunda roses. The flowers melt into the surrounding washes and are saved from being too sweet by snippets of crisp drawing in leaves and buds. Soft pinks hint at further clouds of flowers beyond.

project . . . Using negative shapes

✦ Place some flowers in front of a paler background or against the light. Look at them through half-closed eyes and, ignoring the actual subject itself, study the spaces in between. There may be masses of overlapping petals and leaves all round. Let these blur together as one complicated shape and do not be distracted by them.

✦ See how the light gaps are like geometric designs – wedges, triangles, lozenges, diamonds, hexagonals and other abstract curved or crooked patterns.

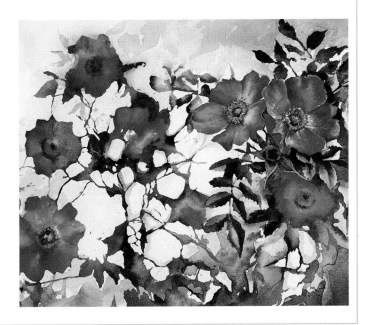

▷ **Red Roses** *21 x 30 cm (8¼ x 11¾ in)*

Simplifying flowers

At this time of year the warm weather encourages flamboyant flowers that at first glance are terrifying to the artist. There are spires of bells and trumpet shapes or pom-poms with layers of petals, as well as complex massed groups of plants that seem a nightmare to paint. If you squint at such flowers through half-closed eyes they will immediately look a little easier to tackle. It simplifies them by reducing the detail and concentrating on the overall effect. The trick of painting a difficult structure is to be very selective.

Using lights and darks

A strong light source will also help break the structure into simpler areas. When painting inside you can cheat with a directional lamp, but if this is to be an outdoor subject you will need to wait for a sunny day. Try to reduce the patterns of light and shade to roughly three tonal values - pale, medium and dark. Some of these areas can be shaded together, with the bits you want to focus on left as crisp shapes. A small pencil sketch before you begin should help to clarify your tonal values.

Avoiding detail

The decorative details, textures, patterns and incidental shadings within each element can be ignored for the time being, to be added later after you have established the general structure. The same applies to subtle colorations. The secret is to try to grab the overall colour scheme initially, allowing each colour change to flow from one into the other and minimizing unnecessary edges and brush interruptions.

▷ Some angles are easier to paint than others, so it pays to examine your flower from all positions before starting work. A profile is often easier to paint than a flower that faces you.

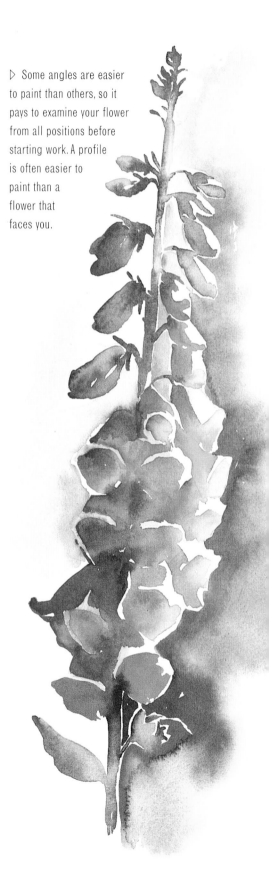

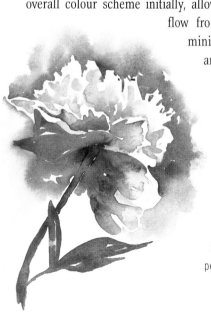

◁ If there is a strong light on the flower do not be afraid to let the white of the paper be your lightest area. See how a carefully drawn profile and a few dabs of paint describe the ragged, random fussiness of the top petals of the peony in this painting.

project . . . Tackling a complicated group

✦ Where a patch of flowers is crowded together, look at the overall shapes that they make instead of straining your eyes to distinguish which flower belongs to each stem.

✦ Draw the profile or outline very carefully, paying particular attention to the smaller features which break away from the bulk of the clump, like the buds at the top of these delphiniums.

✦ Describe carefully the negative gaps where lighter or darker patches peep through. These shapes will help define the characters of the flowers.

✦ Paint wet-into-wet washes over the whole group, varying the tone or colour if needed as you progress.

✦ Use a minimal amount of detail within the washes. It is not necessary to paint every petal or flower. Choose a few dominant ones that, for example, are at the front or catch the light, and the rest can be conveyed with simple texture or washes.

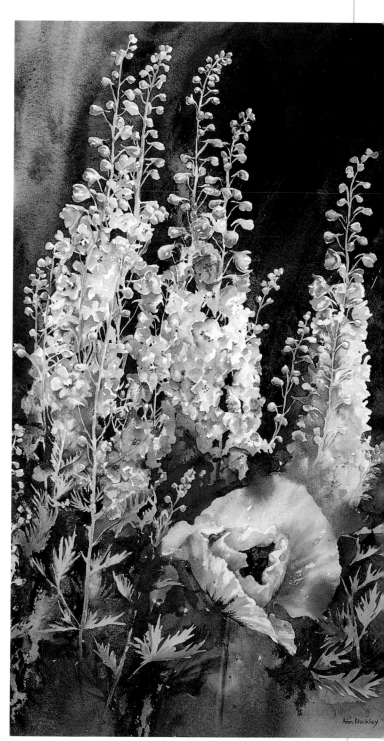

▷ **Delphiniums and Poppy**
71 x 55 cm (28 x 21³/₄ in)

45

Combining flower types

The variety of flowers this month makes it a good time to try combining flower types in your pictures. There are even greater opportunities for exciting compositions when you juxtapose quite different plants with varying characteristics. In my own pictures I prefer to stick to a maximum of three different species as any more than this could become a bit too busy.

▽ **White Roses and Geraniums**
20 x 17 cm (8 x 6¾ in)
This garden corner wove together three sorts of flowers. I focused attention on the large roses and sprinkled in smaller geraniums. Violas were dotted into the background to contrast with the foreground flowers.

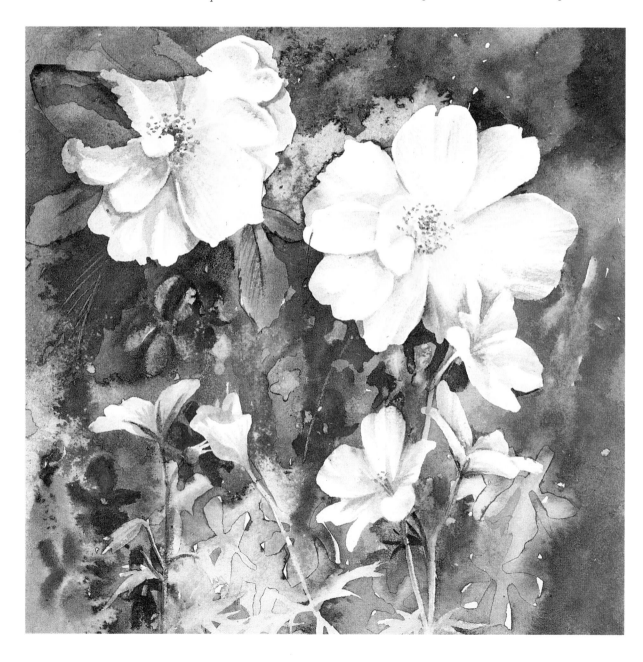

△ **Cottage Garden**

49 x 38 cm (19¹/₄ x 15 in)

In this painting of a complicated cottage garden
I selected three species of similar upright structures.

Your combinations should be of flowers that echo each other or have something in common that will link them, such as similar shapes, growth patterns or colour. Conversely, there should also be an area of contrast. This is important in adding interest to the picture; that element of spice to add life to the composition.

My own method is to mix flowers and plants for their visual qualities first, whether they are similar or opposites. I am then careful to combine them in a natural way, using their traditional, botanical, geographical or seasonal associations. For example, red roses are more suitably grouped with delphiniums rather than with an exotic hibiscus, even though the latter may share the rose's hue.

Mixing bright colours with sombre ones, dark with pale and warm with cool will provide visual interest in your pictures. This can be taken further by setting large shapes against small, curved against angular, upright against horizontal, thin against fat and simple against intricate. You need only think of the difference between a tubular foxglove flower, an open single rose and a shaggy double peony to appreciate the incredible variety of form that plants offer.

project . . . Combining your favourite flowers

✦ Paint two pictures, using combinations of some favourite summer flowers. To keep it simple use only two or three different types.

✦ For the first picture, choose flowers that blend harmoniously. They could be different shades and tones of the same colour or a range of warm pastels.

✦ For a second version, use one of the flowers again but this time place it next to a new choice of flower in a contrasting colour. When you paint your first washes allow these different colours to merge in places and to link one flower visually with the next.

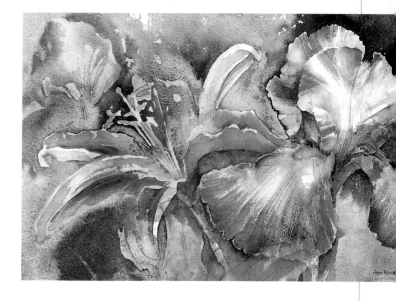

△ **Lily and Iris** *25 x 41 cm (9³/₄ x 16 in)*

demonstration . . . Sweet Peas

*Small, climbing flowers make loose decorative patterns.
In this painting of sweet peas I used straight stems and
curling tendrils as structural features in order to give
their random meanderings some geometry and design.
I liked the sugar almond colours and translucency of the
delicate flowers.*

COLOURS

Alizarin Crimson
Burnt Umber
Cadmium Yellow Pale
French Ultramarine
Hooker's Green Dark
Permanent Rose
Purple Madder

▽ **Stage 1**

My starting point was to draw the outlines of the
flowers and leaves as abstract shapes, especially
where they overlapped. I emphasized the main
stem so that it divided the picture into separate
areas. This enabled me to paint in sections. I used
pale variations of all the colours to make wet
washes that ran into marbled backruns.

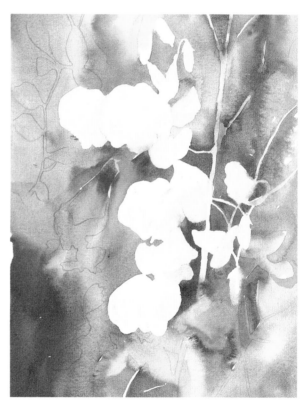

△ **Stage 2**

I continued the washes, leaving white paper for
some of the stems and the main sweet peas. When
the paint was still damp I flooded in patches of
diluted Alizarin Crimson to make the background
flowers. I painted over the pencil marks that
outlined secondary leaves, but the watercolour was
pale enough for me still to be able to see them.

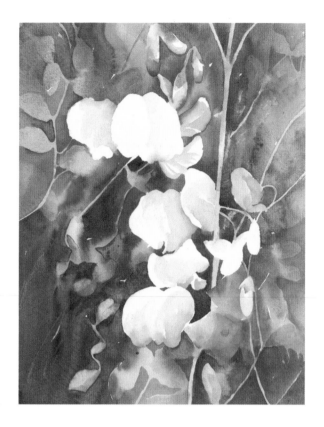

◁ **Stage 3**
Pale or negative leaves and stems were described by painting darker colour into the spaces surrounding the pencil outlines. Then I used the same stronger paint to brush 'positive' or dark leaves on top of the pale background. Next I began to fill in the sweet peas using the pink colours and some of the green background colour.

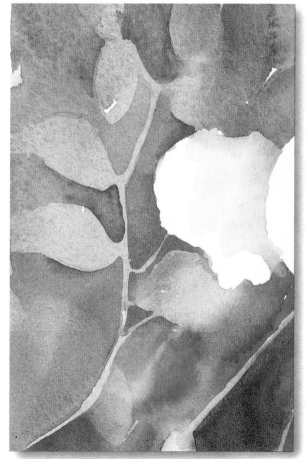

▷ **Detail**
This detail shows how I made leaves and stems appear from out of the first wash by painting dark colour into the negative spaces. It is important to blend the new colour into the existing wash, using clean water to avoid an outline or halo effect. The initial wash should be dry before you attempt this in order to retain crisp edges around the emerging leaves.

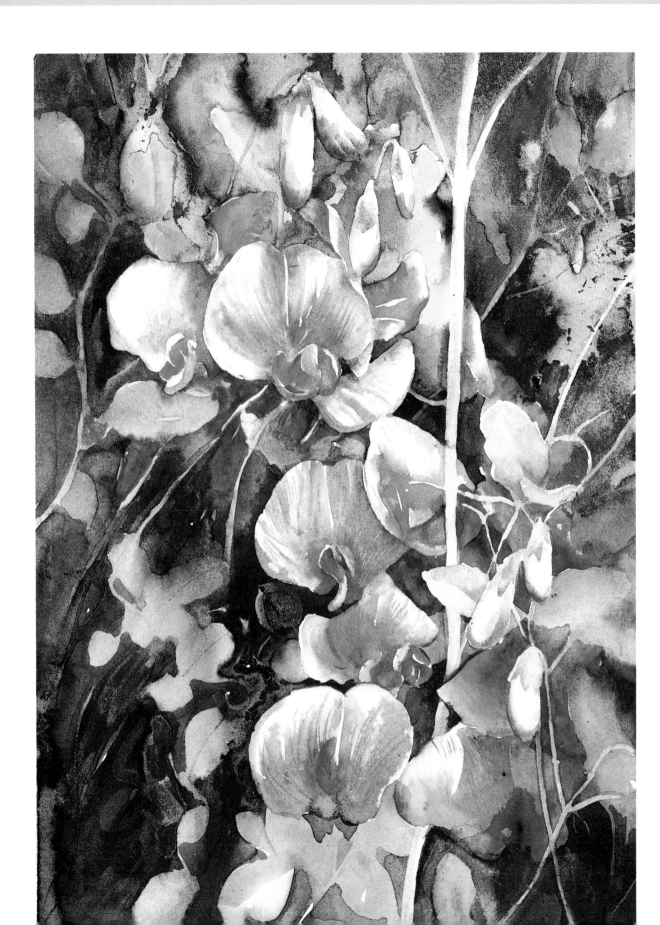

◁ Stage 4

I strengthened the background and finished the sweet peas, letting some of the white paper show through for highlights. I used strong paint especially at the base of the flowers to give them a similar tone to the background and help link the two together. I painted the gentle striations of the petals by splaying out the brush hairs and dragging the paint downwards.

◁ Sweet Peas
29 x 17.5 cm (11¹⁄₂ x 7 in)

FURTHER IDEAS

Now paint a quicker, more spontaneous version, keeping the watercolour pale and translucent. Enjoy again the design possibilities of the flowing outlines but this time try to think of them in looser, more abstract terms. Choose a different climbing plant such as honeysuckle or clematis if you want a change.

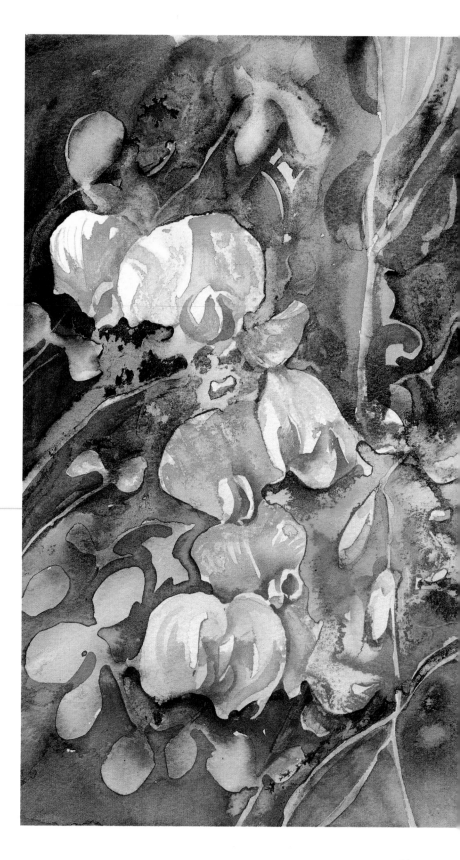

▷ Sweet Peas 2
29 x 17.5 cm (11¹⁄₂ x 7 in)

july

Shady trees act as parasols, giving shelter from the sultry heat and glaring sun. The garden is sweet with ice-cream colours and spiced with bright patches of deckchair brilliance from hanging baskets and patio pots. A holiday atmosphere tempts us to pack our kit and travel outdoors on painting trips.

A month for play

I love the whimsical names of many July flowers – foxgloves, snapdragons, forget-me-nots, honeysuckle, love-in-a-mist. They conjure fanciful images straight out of a children's storybook. I sometimes try to include elements of fantasy in my pictures, such as the gold ink behind the foxgloves opposite. This rich texture owes nothing to reality; it is purely decorative and great fun to try for a change. This month is a good time to relax and enjoy yourself.

▽ **Honeysuckle**
36 x 33 cm (14^{1}/$_{4}$ x 13 in)
The gradual increase in size and clarity from small blurred suggestions to large detailed study helps give a sense of depth to this hedgeful of honeysuckle.

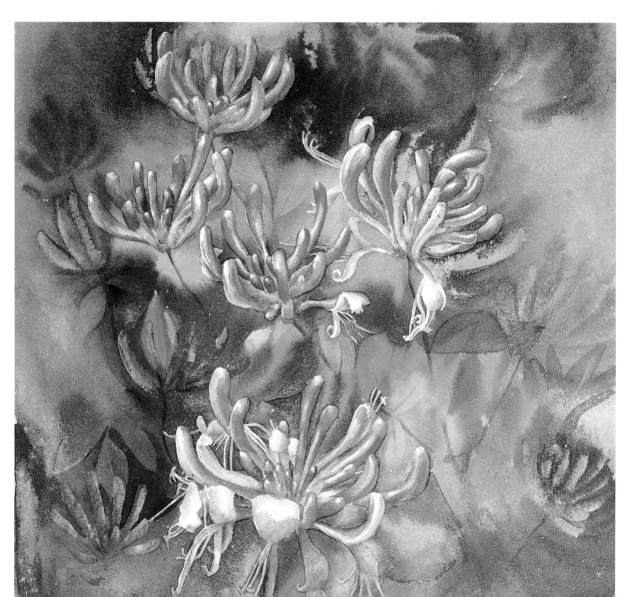

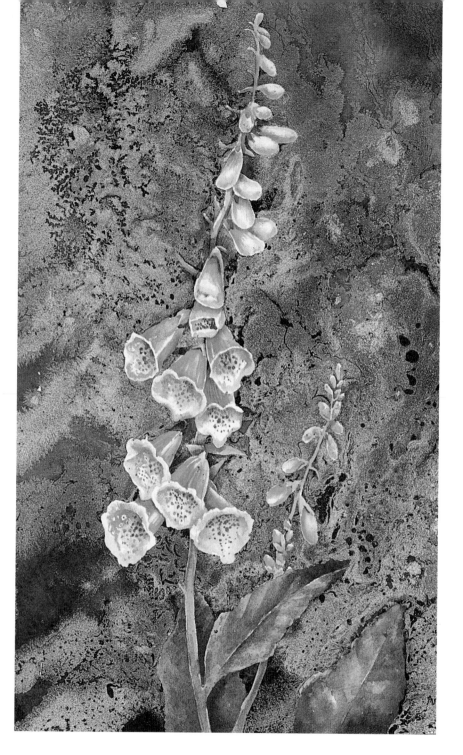

38 x 28 cm (15 x 11 in)
The spattered, marbled texture of the background echoes the mottled, dappled markings inside the foxglove bells. I also used shades of Viridian and Purple Madder to link the two elements of flower and backdrop.

Out and about

Why not take a break from finished paintings and do a series of quick sketchy pictures outside? It is a chance to make the most of the good weather and work outdoors whenever you are able to. You may have to revise your techniques, as you have to work very quickly in hot sunshine. Wear a sunhat to shade your eyes from glaring white paper. Sunglasses are not a good idea as they distort tones and colours.

You could put away your collection of outdoor work until gloomy winter, when you could do more detailed versions, tidying up compositions, enlarging a sketch, or combining elements from different pieces to make a new picture to cheer you up.

Painting outdoors

Long, warm, dry days coax us outdoors to paint, and it is a good idea to prepare your equipment so that it is ready to be taken out on trips at a moment's notice. I take a lightweight folding easel and stool, a folding water pot with a handle to hang on the easel, paper, paints, brushes and a palette. The other important ingredient is water, which I keep in a large plastic milk bottle for expeditions. If you limit your equipment to the bare essentials it will make life easier. Leave fancy techniques for indoor work.

On summer days the temperature and humidity can really affect the drying times of watercolour. A warm breeze is an even worse culprit, as it dries the paper quickly and also blows the flowers around while you are endeavouring to paint them. Changing light, chasing shadows and the glare of white paper also add to the challenge.

Try to regard all of these factors not as problems, but as positive ingredients that create the atmosphere of the outdoor scene. It is a chance to feel the flowers and sense them living and growing from the earth rather than being stuck in a vase inside, so smell the fragrance, see the sunlight bleaching the colours and listen to the bees humming. Soak up the feeling that this evokes then transfer the experience to paper, trying to paint what you feel as well as what you see. Working quickly and spontaneously will not only help you to capture the essence of a scene, it will also make it easier to cope with the restrictions that outdoor work presents.

△ **Sunny Poppies Step 1**
This was painted on a very hot day, so plenty of wet paint was mixed to combat the drying influences of the sun. Dazzling light bleached the poppies to mauves, yellows and salmon pinks that suggested a sultry day.

▽ A thumbnail sketch showing tonal values and shadows will help you with your paintings later on. If the light has changed or a petal has moved or dropped off, this record will remind you of how the subject looked when you started.

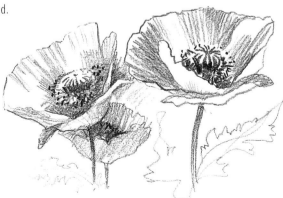

✦ Painting quickly does not mean carelessly. Take enough time to observe your flower and record its main characteristics. Draw an outline first if it gives you confidence, but do not be afraid to paint over your pencil marks later.

✦ Mix more colour than you think you could possibly need. You do not want to have to stop halfway for fresh supplies.

✦ Limit yourself to about 30 minutes. This will make you concentrate on the wider issues rather than detail.

✦ Use a larger brush than usual. Invest in a size 16 or more – it does not need to be an expensive one. Lock up anything under a size 4!

▽ **Sunny Poppies Step 2** (unfinished)
In the first stage the paint was allowed to run, but now it was brought more under control. The flower layers were built up with shadows that hinted at the ridges in the transparent petals. Detail was limited to the centre.

▽ **Waterlily** *21 x 22 cm (8¹⁄4 x 8¹⁄2 in)*

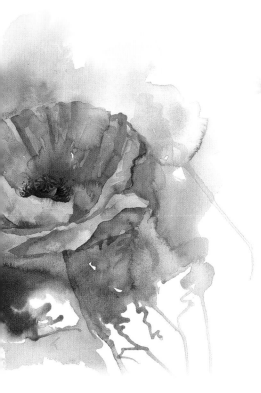

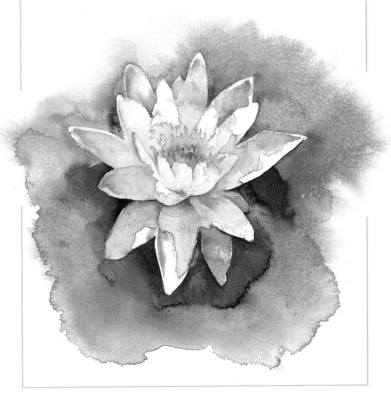

Painting on holiday

Painting on holiday should be a relaxed, casual affair indulged in for the sheer pleasure of recording the flowers. Such paintings are a wonderful souvenir to look at later, just as you would take out your holiday snapshots. What I enjoy most is the lack of pressure to perform. These are not paintings for display to others but purely private explorations that no one else need ever see.

On foreign holidays you may come across unusual flowers with exotic-sounding names like passion flowers and birds of paradise. Their vivid hues are intensified by deep blue skies and you will need a good range of colours to record flowers such as this. However, if you want to travel light you can just take a small box with pans rather than tubes of paint. The aim of holiday painting is to record things you see and not necessarily to explore techniques.

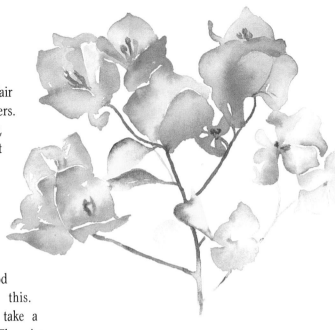

△ I tried to simplify the complex origami tissue paper shapes of bougainvillea.

▽ I used the backdrop of a mountain to throw this hibiscus into relief – and to remind me of the view from our holiday villa.

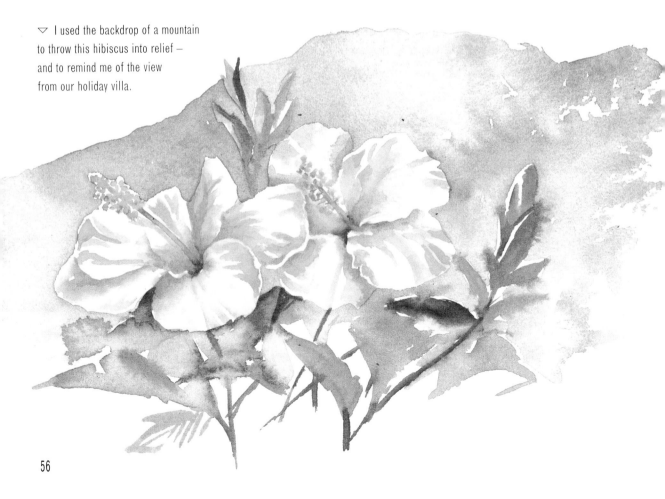

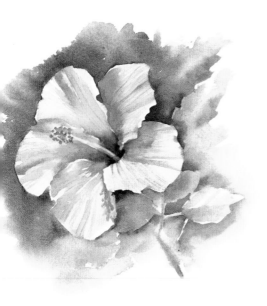

△ I painted this hibiscus while on holiday in Gran Canaria.

project . . . Keeping a visual diary

✦ Start to keep a diary using a sketchbook to make a visual record of the things you see. These could be random observations or a careful exploration of plants developing through the seasons.

✦ Keep a variety of drawing and painting materials to hand so that you can choose an appropriate medium for your notes. Use crayons and watercolour pencil for quick dashes and dots of colour, pencil or pen and ink for monochrome studies and watercolour for splashy marks and colourful sketches.

✦ Fill your diary with drawings, paint sketches and ideas. These could vary from detailed and complete garden scenes to 30-second doodles of petal markings or a single leaf. Write notes too if you like and add pressed wild flowers or anything else that helps to create a personal statement.

△ I like the twisted curls of orchid petals and their mysterious hieroglyphic markings.

Flowers in settings

When I am out and about my eye is constantly on the lookout for new floral subjects. Flower colours act like a magnet in surroundings that may otherwise be quite sombre. In a town, balconies and window boxes are ornamented with pots and baskets that cascade with waterfalls of colour. In the country, ramshackle barns are fringed with willowherb and crumbling walls are studded with wildflowers. In the garden, expanses of lawn are broken by flowerbed vistas and by the house, where patios, walls and doorways lure us with floral decorations. Looking at flowers in these different settings gives us exciting opportunities to play with contrasting textures that are not normally relevant when painting flowers on their own.

In scenes like this, flowers are often an added ingredient or embellishment rather than being the centre of attention. Their individual shapes are lost in the mass of other flowers and foliage. They can be painted just as washes of colour or with dots and small brushmarks that just hint at their character.

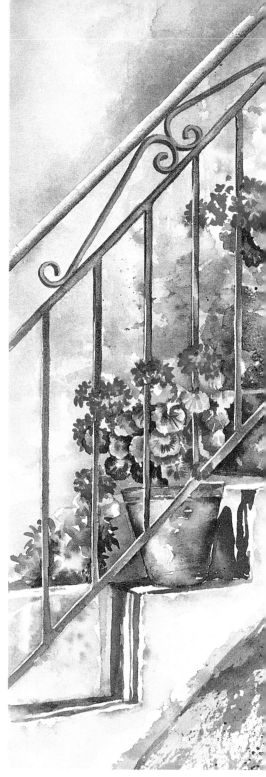

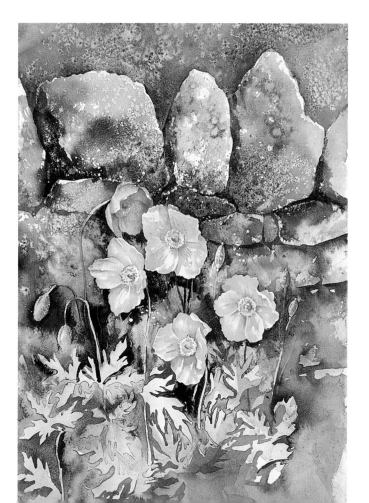

◁ **Welsh Poppies**
26 x 18 cm (10¹/₄ x 7 in)
The rough textures of the country wall are an excellent foil to the transparency of the poppy petals. To build up the mottlings I spattered masking fluid then applied a variegated wash. I dripped in other colours and scattered salt on to the damp paint to break up the surface.

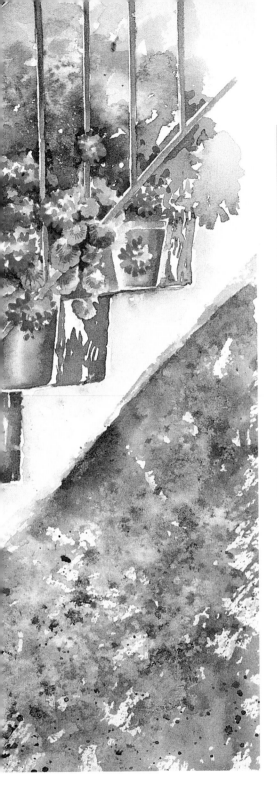

project . . . Painting garden features

✦ When you are painting flowers in settings you may be faced with patterns and geometric shapes in manmade features. Try using a flat-edged brush for short straight lines or dragging paint with the flat end into rectangles for brickwork and steps.

✦ You could begin by making a drawing of your chosen garden corner. Break down the subject into areas of interest, using different marks to describe the varied textures of background, floor, flowers and features.

✦ Now do a watercolour version. Paint the flowers very simply, distilling them down to a series of marks and suggestive colour. Paint the other features with a selection of textures such as wax resist for bricks, scratching and scraping for wood or washing off for stonework.

▽ **Archway** *19 x 14 cm (7¹⁄₂ x 5¹⁄₂ in)*

△ **Up the Steps**
23 x 17 cm (9 x 6³⁄₄ in)
These red geraniums were painted as simple daubs of colour against the sombre building textures. The mottled walls were developed through a series of blotting and splattering methods.

demonstration . . . Hollyhocks

This romantic riot of cottage-garden flowers could have been a visually confusing composition but was tamed by means of focusing upon a single pale hollyhock, luminescent against a rich, busy background of flower impressions. This contrasted with the darker hollyhocks silhouetted on a light, restful area on the right-hand side of the composition.

COLOURS

Alizarin Crimson
Cadmium Yellow
Cobalt Blue
Green Gold
Indanthrene Blue
Indian Yellow
Quinacrodine Magenta
Sepia ink

▽ Stage 1

I drew the outlines of the prominent hollyhock, adding a few leaves and abstract marks for those in the background. I painted the dark hollyhock with strong paint, using Cadmium Yellow with Indanthrene Blue for the greens and Alizarin Crimson, Quinacridone Magenta and blue for the flowers.

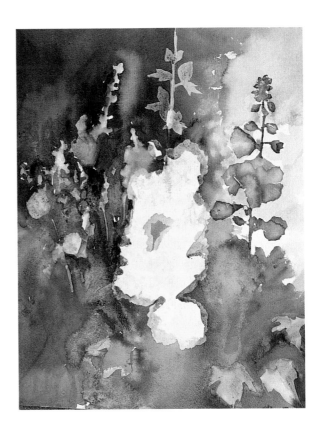

△ Stage 2

After masking the central flower I painted washes in the background, indicating the loose flower shapes. I used Indanthrene Blue both on its own and with Indian Yellow, introducing a drop of Sepia ink at the top and Green Gold at the bottom. I used mixtures of the reds for the background flowers.

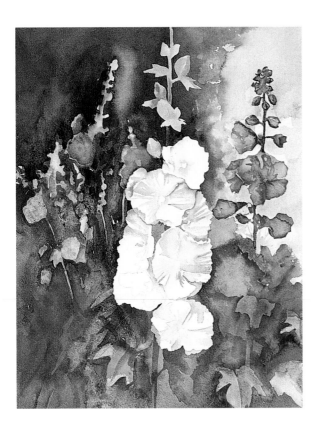

◁ **Stage 3**
I removed the masking fluid then began to fill in the pale hollyhocks, using pale washes of Cobalt Blue toned down with touches of dilute background colours to describe the crumpled tissue paper effect of the shadowed petals. The glowing centres are Cadmium Yellow.

▷ **Detail**
The abstract background marks were turned into flowers by redefining the edges and adding little touches of detail such as the flower centres and the roundness of the buds. That was all that was required to hint at their identity. The viewer assumes that they are hollyhocks because they are roughly the right shape and colour and are viewed in the context of more realistically described flowers.

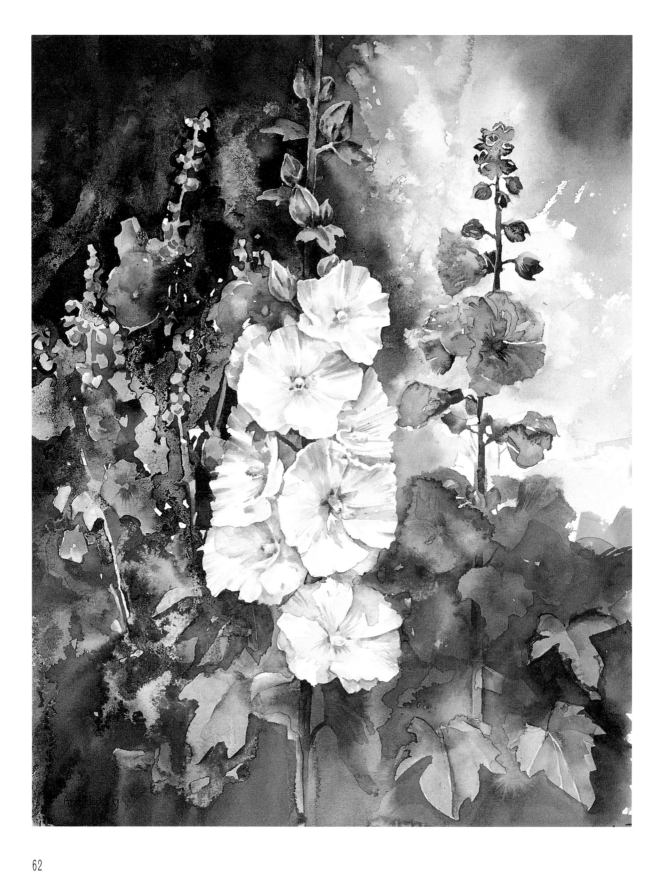

◁ Stage 4

I added further detail to the main hollyhock, trying to keep the flowers clean by not overdoing them. Notice how the yellow of the centres reflects on to other parts of the petals. I softened some of the previously masked edges by dampening parts of the adjoining background and brushing inwards to make links with the flower. I added a little more work to the dark hollyhock but was careful not to let this compete with the focal point.

◁ Hollyhocks
40 x 28 cm (15³/₄ x 11 in)

FURTHER IDEAS

Before you start painting, cut your paper into a shape that reflects the character of the flower. If your subject is still a hollyhock you could trim a third off the length of a full sheet of watercolour paper for a tall, narrow piece. Paint a single stem that stretches from bottom to top. If you want to include one or two more stems you could do another slightly wider version.

▷ Red Hollyhocks
28 x 20 cm (11 x 8 in)
The pale negative shapes behind these hollyhocks were blocked out with masking fluid before filling in the flowers and stems with fluid watercolour. This lends a sharp, chiselled look to the edges.

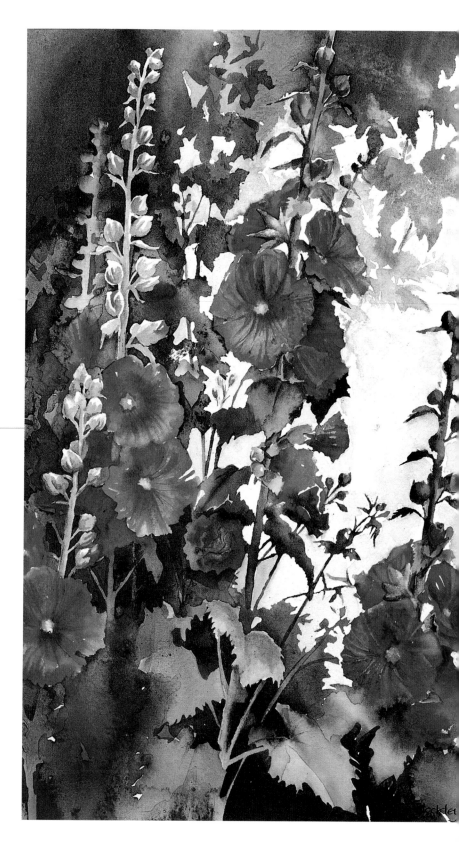

august

From afar the parched August landscape is a medley of mellowed hues, but viewed close up each patchwork piece unfolds with a different story. Cornfields, tanned golden-brown, are stained and flecked with poppies. The vegetable allotment reveals shapes and forms of every size and texture, while the bright patterns, spots and stripes of the garden tell a cheerful tale.

Studying detail

You will find a whole new world of pattern and texture if you take a magnifying glass around with you this month and examine at close range the flowers, vegetables and plants that you see. Look at the plaited rows of wheat in ripe cornfields, smell the dust and hear the dry rustle of the grasses. Then decide how you would paint these hard edges and dry surfaces.

If you study the giant-sized dark centres of sunflowers over the month you will see them evolve from an infinite mass of tiny florets to an intricate design of seeds. Trying to paint each with photographic realism would be impractical, so your aim should be to convey the general effect rather than aiming for botanical accuracy.

▽ **Oriental Poppy** (detail)
This was painted very quickly, using large pools of colour. The background was slashed on with a 6 cm (2$^1\!/_2$ in) decorator's brush and the vivid reds and oranges on the poppy were accentuated with black Indian ink.

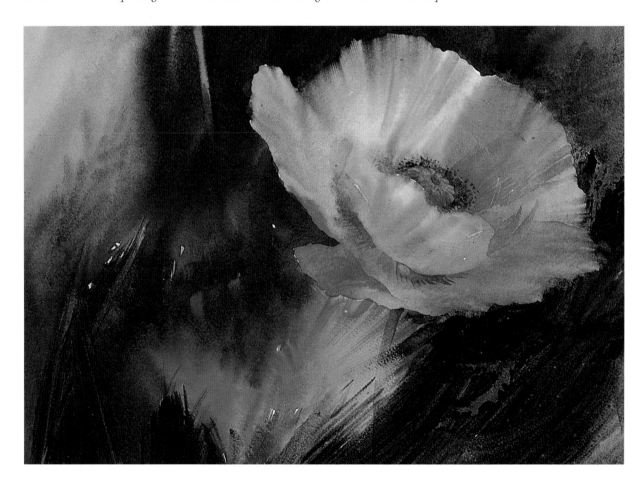

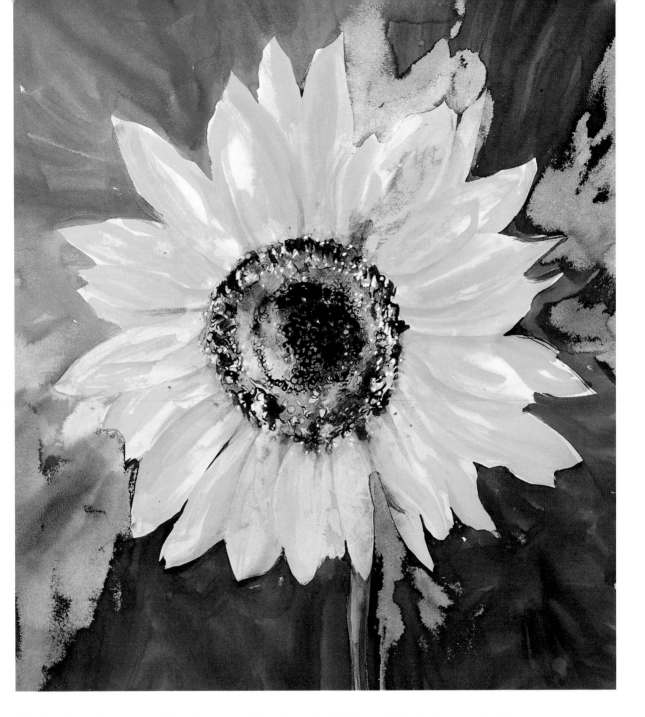

This is a time when you could continue to work outdoors, but if the sun is too hot you could move inside to play with the kaleidoscope of patterns you have found.

Be big and bold

The very names of August flowers such as red hot poker conjure images of warmth and sunshine, and your palette can dazzle with the oranges of marigolds and the cerise of fuchsias. Late summer flowers spell blatant excitement. The small sprigs of springtime have been ousted by large, confident growth: tall verbascums, rounded pumpkins and huge heads of hydrangeas. These exuberant subjects call for acres of rich paint, whole sheets of paper and even the use of a 6 cm (2¹/₂ in) decorator's brush. Painting on a grandiose scale can be a liberating experience.

△ **Sunflower**

45 x 42 cm (17³/₄ x 16¹/₂ in)
I summarized this sunflower with graphic simplicity, using a bright yellow that glows against the deep blue. The flower centre was treated with a variety of abstract scribbles and dots, drawn with pen and ink on top of a dry, dappled wash.

Patterns and textures

There is a wealth of patterns, markings and textures to be found in the miniature landscapes of plant life. Spots, stripes, patches and rings of colour adorn flowers like decorative butterfly wings. The formations of the petals themselves create textures. These vary from carefully arranged spirals to frilly, many-layered pompoms. Multitudes of tiny close-knit florets, buds or seeds form random lacy designs. All these marks can be painstakingly rendered with precise brushwork but I prefer searching for alternative, descriptive methods.

◁ Paint irregular petals such as those of carnations by twisting the brush hairs around to leave rough edges. Leave a few white gaps between the shapes, then drop water into the drying paint to disturb it into random markings.

△ Paint a sunflower or similar species with a solid layer of watercolour, then touch a drop of Sepia ink into the middle. The ink will flood outwards in an uneven cloud shape. Prick out a few highlights from the dry centre with the tip of a scalpel.

▽ Make lacy textures such as the middle of hydrangeas, sedums and lilac using a natural sponge. Dip it into dilute paint and press lightly onto the paper, building up the shape you want. Vary the colour with each application, but do not overdo it.

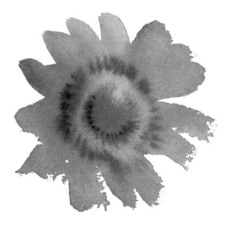

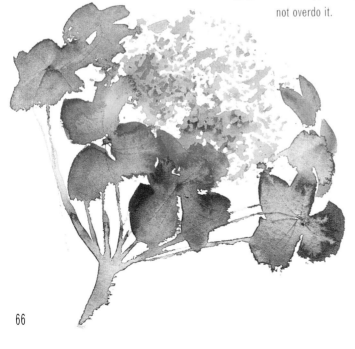

△ Rings, blobs and petal marks can be painted wet-into-wet for a soft interpretation. Paint flowers as solid shapes then drip the different colour into the centre. Finish with tiny dots of paint to form a circle. Try other variations on this theme – the options are endless.

project . . . Painting larger than life

✦ Take a single flower with an interesting centre, markings or texture. Enlarge it so that it is much larger than life and fills your whole sheet of paper.

✦ Think about those puzzles where a subject is magnified out of recognition and becomes just an

abstract texture. Now look closely at the surfaces of your flower and try to see them in a similar fashion.

✦ Find techniques that describe the patterns you see. You may need to build them up in layers using a variety of methods.

▽ **Portrait of a Lily** *45 x 45 cm (17³⁄₄ x 17³⁄₄ in)*

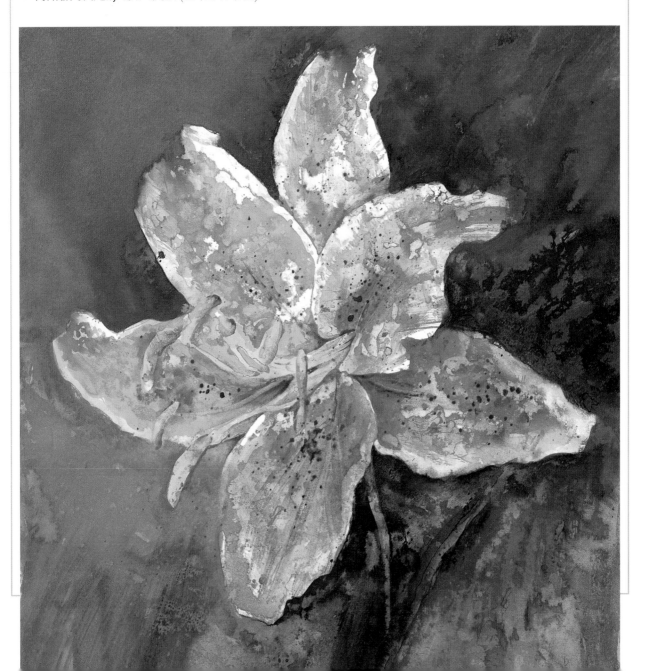

Hot colours

As the garden heats up in August the colours become richer and warmer. These hot, intense shades almost bring alive the heady perfume of the late summer garden.

When you put together a range of warm pigments in a painting you do not want to produce the sickly effect of an over-rich pudding. However, you can easily counteract the sweetness with something sharp or a total contrast. This balance could be provided by a dark tone or a cool colour. Prussian Blue or Indigo would be a good choice for cold, watery subjects, while Cobalt Blue and French Ultramarine have warm undertones.

▽ **Lily Flames**
33 x 40 cm (13 x 15³/₄ in)
In the painting of flowers I try not to be pedantic with colour matching. Rather than just using one orange for this lily I have drawn on a whole range from salmon and peach to copper and gold. A dark background throws the colours into relief. To keep your colours powerful you need to mix them to a rich, creamy consistency, though you may wish to dilute a little more on paper as you shape petals to retain some of their transparency.

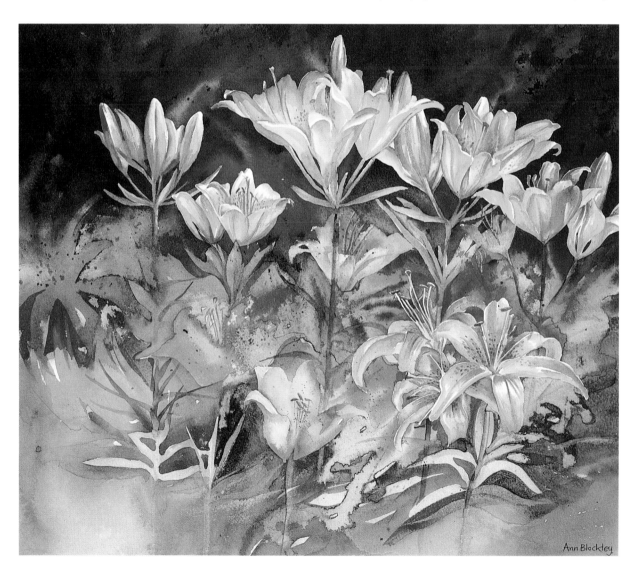

Ann Blockley

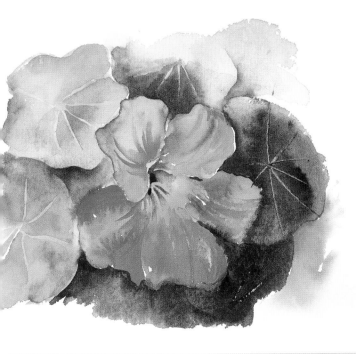

◁ Sometimes it is necessary to exaggerate and invent colour schemes to serve a purpose. These nasturtium leaves were a slightly boring shade of kiwi fruit green, so I introduced warm oranges to link them to the flowers and hints of blue to make them sing.

project . . . Flowery doodles

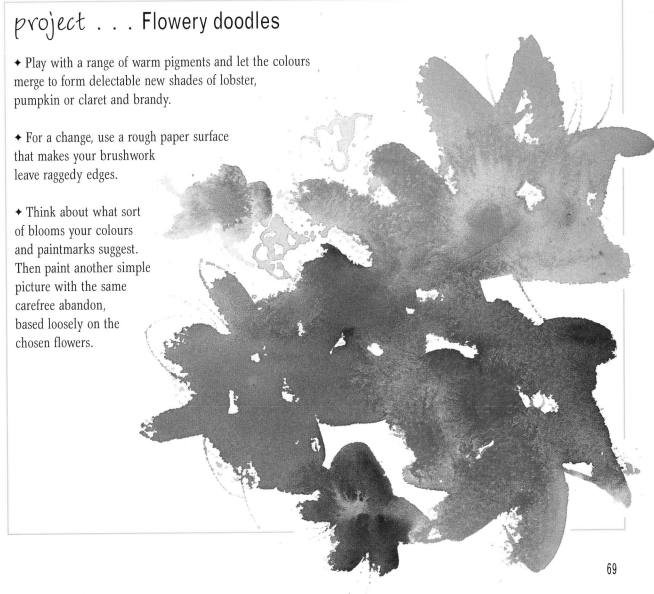

✦ Play with a range of warm pigments and let the colours merge to form delectable new shades of lobster, pumpkin or claret and brandy.

✦ For a change, use a rough paper surface that makes your brushwork leave raggedy edges.

✦ Think about what sort of blooms your colours and paintmarks suggest. Then paint another simple picture with the same carefree abandon, based loosely on the chosen flowers.

Exploring the vegetable garden

In late summer the vegetable plot as well as the flower garden and surrounding countryside can become tedious with an endless sea of repetitive greens; the fresh, luscious growth of spring has become tired and jaded as it matures. However, if you stop and look a little closer at individual leaves, stems and vegetables you will see an enormous variety of colour from olive and emerald to chartreuse and bottle-green.

Once you view the vegetable plot with new eyes a whole vista of fresh painting ideas will extend before you. There will be a medley of shapes, forms, textures and extremes of sizes rare in a flower garden. Wheelbarrow-filling pumpkins contrast with miniature peas, while marrows the shape of air balloons and narrow spears of beans jostle for space. Surfaces range from the mirror gloss of aubergines to wrinkled cabbages and knobbly cauliflowers. This rich variety can be another source of inspiration in your pictures.

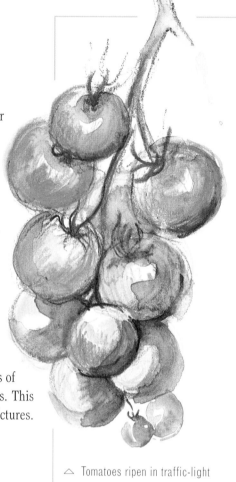

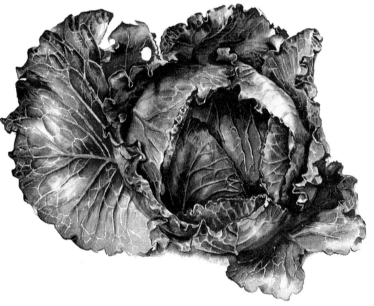

△ The heavily veined, map-like leaves of cabbages are a great subject to explore — and the more caterpillar holes there are the better for the artist!

△ Tomatoes ripen in traffic-light fashion from green and amber through to red. I used a combination of wax crayons with watercolours to make a sketch. Notice how I employed a mixture of blue and yellow crayons in places to describe the green of the tomatoes.

▷ For these beans I mixed greens from French Ultramarine, Cobalt Blue, Green Gold, Hooker's Green Dark, Quinacridone Gold, Indian Yellow, Cadmium Yellow and Process Yellow ink. The warm colours were Cobalt Magenta, Alizarin Crimson and Cadmium Red.

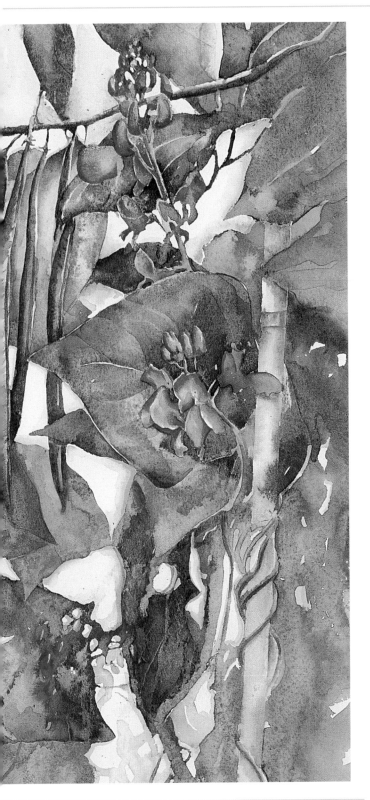

project . . .
Mixing a range of greens

✦ Paint vegetables as if they were growing in the garden and see how many different shades of green you can find in them and their leaves.

✦ Try mixing your greens in two different ways, first taking green-based pigments such as Hooker's Green Dark or Viridian and mixing them with tiny amounts of other colours to turn the greens more blue, brown or yellow. Secondly, mix blues with yellows or oranges.

✦ Make some greens dark and intense by using thick paint and others pale and translucent by adding more water.

✦ Introduce other pigments so that the green shades evolve into new colours such as orange, purple or red. Such colour variations might occur when the vegetables are ripening, when light is shining on leaves, or when coloured flowers are reflected on glossy surfaces.

▽ The three elements of this squash form excellent contrasts. The large rounded pumpkin offsets the intricacy of the foliage. The orange flower has zigzag angles and a depth to its trumpet structure that is a foil to the flat leaf shape.

demonstration . . . Poppies

In this painting scratchy, brittle lines of barley slash through rounded silk scraps of crimson poppies. A variety of hard scraped edges and soft smudges creates a contrast between the stiff, ripe corn and the delicate petals.

COLOURS

Burnt Umber
Cadmium Red Deep
Quinacridone Gold
Sepia ink

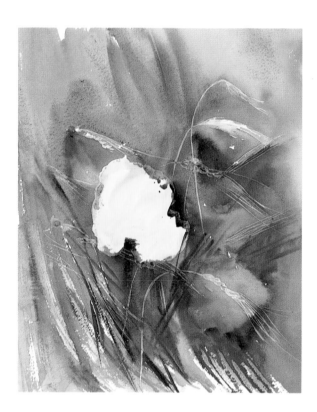

△ Stage 1

I masked a central poppy with a brush and used a pen to mask the stalks and tassels of the corn. The positions of several other poppies were roughly indicated with a pencil. Next I drifted washes of Quinacridone Gold and Burnt Umber all over the paper, letting white paper sparkle through in places. After brushing patches of diluted Cadmium Red Deep onto these washes to suggest poppies I added soft linear marks and shadows with Sepia ink.

▽ Stage 2

While the paint was just damp and the masking fluid intact, I trickled a little clean water into the smoothly blended wet-into-wet wash to roughen it up and create a slightly more textured background. I scratched lines with a scalpel to give a criss-cross mesh of stalks. When this was dry I removed the masking fluid.

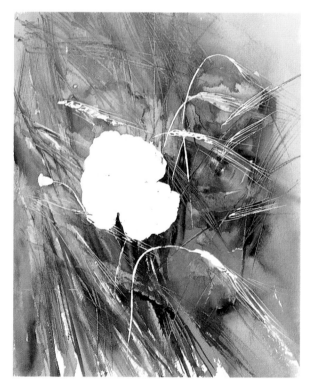

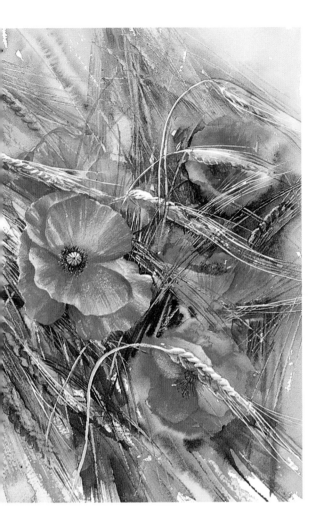

◁ Stage 3

I painted a dilute wash of Cadmium Red Deep over the white poppy, gradually building up layers of petals with progressively stronger colour. It was vital to allow it to dry between each stage. I introduced more explanatory markings into the corn and softened any glaring scratches of white with dilute versions of the original washes. Finally, I flicked in the centre detail on the poppies with a size 2 brush, using dark sepia ink to make an eyecatching focal point.

◁ **Harvest Poppies** *32 x 24 cm (12¹⁄₂ x 9¹⁄₂ in)*

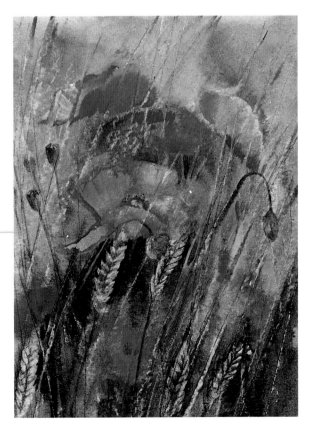

FURTHER IDEAS

Paint another version of a harvest field, but this time without using masking fluid. Concentrate on softer marks and textures. Make the background poppies even further out of focus and any central ones misty and blurry-edged. The demonstration shows the harsh, sunlit effect of midday, but the new variation might describe a gentler scene of early morning or end of day.

▷ **Poppyfield** *40 x 32 cm (15³⁄₄ x 12¹⁄₂ in)*

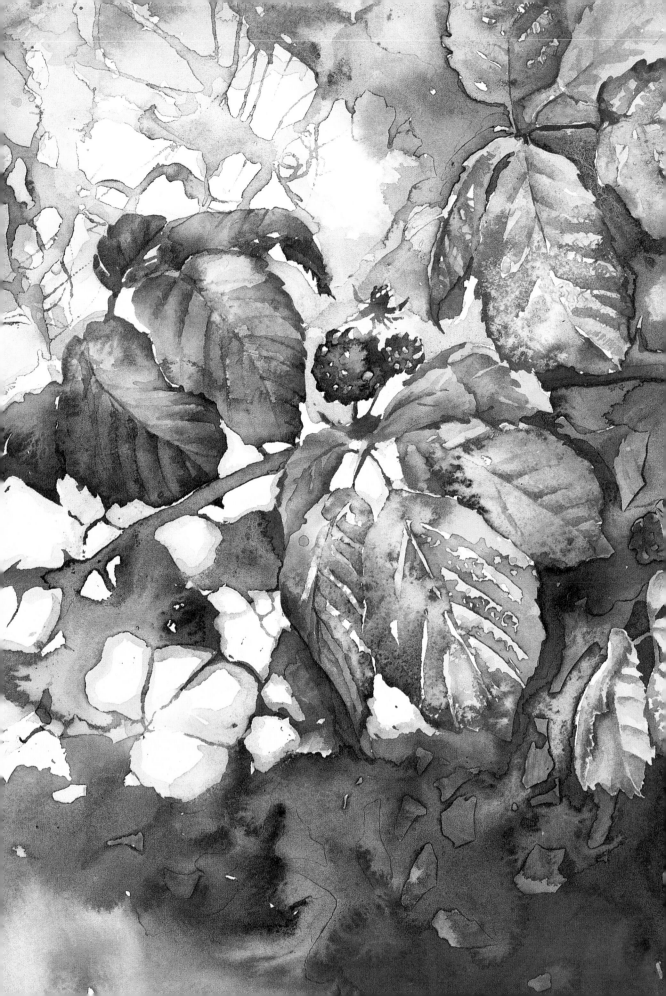

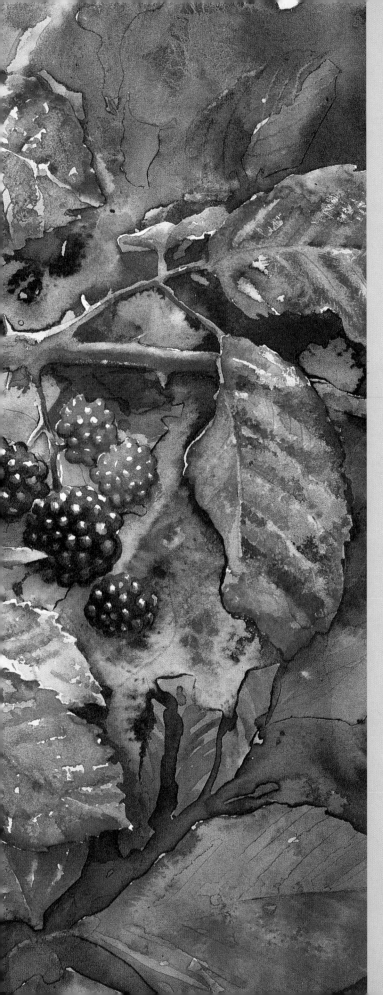

autumn

september october november

It is harvest time in the orchard, hedgerow and garden. Branches are blushed with fruit and gardens are fiery with flowers. Hedges are silvered with old man's beard and wild hops gild the glowing blackberry patch. Birds feast on elderberries that sparkle like dangling jet earrings. Blustery winds shake kaleidoscope patterns of vivid leaves. It is autumn, the season of colour and movement, shapes and texture.

Autumn Hedgerow
28 x 40 cm (11 x 15³/₄ in)

september

September is the month of harvest festival. Crops, hops, seeds and flowers have been gathered, dried and preserved. Trugs full of vegetables, baskets of fruit, sheaves of wheat and jugs of flowers are crammed bounteously onto tables. We painters can celebrate by enjoying and recording this annual cornucopia of different surfaces and textures.

Mellowing colours

The orchard is a source of gleam and sheen this month. Rounded shapes split to reveal glistening, luscious flesh that tempts greedy striped wasps. Chameleon-coloured fruits glow among dark leaves. They invite us to touch and taste, then translate the experience with silky brushloads of juicy watercolour.

The garden is a haze of soft mellow colour. It is awash with Michaelmas daisies, Japanese anemones and sedums in blushing shades of pink, amethyst and magenta. Pale, misty mornings are echoed by clouds of silvery thistledown and spiders imitate these threads of down with their own glistening gossamer webs.

▽ **September Flowers**
25 x 32 cm (9³⁄₄ x 12³⁄₄ in)
These Michaelmas daisies were masked out on a dark background. Another way of painting them on top of a pale wash would have been to employ a series of expressive brushstrokes for each narrow petal.

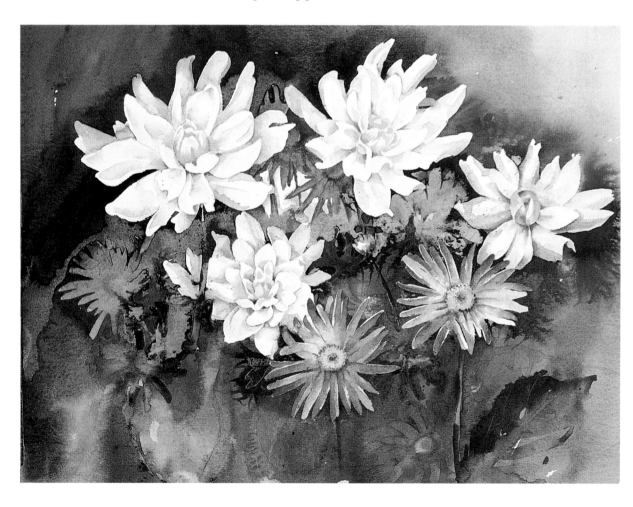

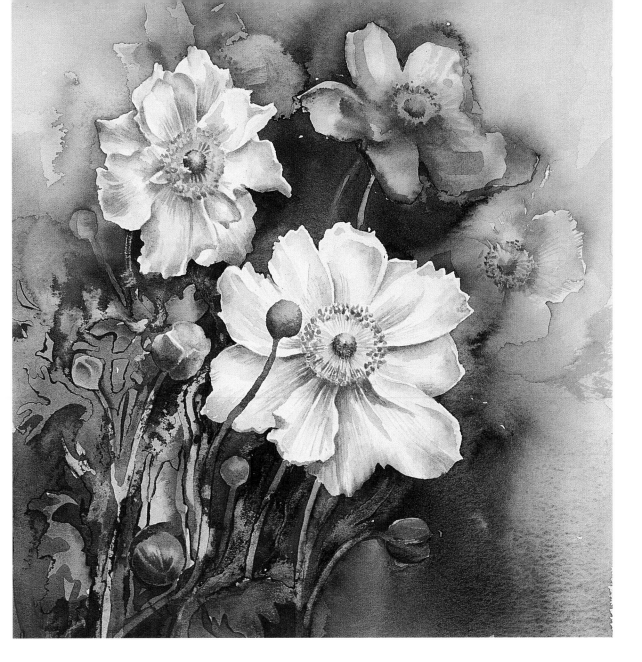

△ **Japanese Anemones**
27 x 22.5 cm (10¹/₂ x 8³/₄ in)
I used a warm palette with which to create these mellow September colours, including Quinacridone Magenta, Cobalt Magenta, Rose Madder, Ultramarine Violet and Cadmium Yellow.

Mists and falling petals touch us with the first hint of autumn melancholy. Then spirits are restored as seedheads assert themselves to reassure us with their promise of renewed delights.

New shapes and textures

A variety of brushwork has suddenly become essential for portraying succinctly the vast array of different textures, finishes and marks not encountered in summer flowers. Hard, brittle stalks, papery seedheads, swaying grasses, velvety-skinned or shiny fruit and furry thistles all demand individual treatment. With one good brush alone you can make broad squiggles, tiny dots or blobs and long strokes of varying width. If you splay brush hairs into a fan you can paint delicate feathery marks, while strong directional brushstrokes can give a sense of movement to stalks and structural plants such as grasses. Where a brush alone fails to meet the requirements you can start to experiment with other texture-making devices.

Seeds and grasses

Seeds and their pods and cases come in all shapes and structures. Some are hard shells, others are soft and squashy; some grow on single stalks, while others are whole constellations of starry patterns. Their fine lines, small marks, brittle stalks, wispy tendrils and intricate constructions demand a look at some new techniques. Scratching, spattering and printmaking as well as different styles of brushwork all make suitable textures. The looser markings you can create with this sort of experimental texture-making are often more expressive than a laborious botanical style.

Brushmarks

Grasses, stems and stalks can often be painted quite simply using single brushstrokes. You may like to invest in some different types of brushes to experience a full range of possible marks. Long, thin 'riggers' are useful for continuous line work and soft squirrel mop brushes for tapering brushmarks. It is worth spending time practising some different marks with a range of brush types and sizes. Try ragged lines, sinuous curls and tapering trails. Include some that are straight, spindly or angular and others that are thick or wavy. Experiment with the amount of paint used and degree of pressure applied. Grass seeds can be painted with texture-making devices or flicks and stipples of the brush.

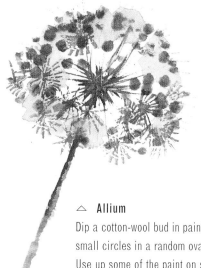

△ **Allium**
Dip a cotton-wool bud in paint and print small circles in a random oval design. Use up some of the paint on spare paper so that the marks vary in density. From a central small pool of paint, drag fine stems, radiating outwards with a sharp point. Build star shapes with the chisel end of a flat brush. Use the same flat edge to make a series of short sideways marks, one below the other, creating a rough-edged stalk.

◁ **Love-In-A-Mist**
Paint the seedhead with blended stripes of colour. Drip water in to make the soft, cloudy markings of this vulnerable, squashy seed case. With the handle end of the brush, drag the wet paint out from the base into swirling, feathery fronds.

◁ **Poppy**
These seemingly uniform grey seedpods actually contain subtly graded colorations. Working with mixes of Burnt Umber, Yellow Ochre, Warm Sepia, Purple Madder and French Ultramarine, paint a continual wash from the ridge into the plump pod and down into the stalks. Make an explosion of seeds using dark paint flicked off a toothbrush.

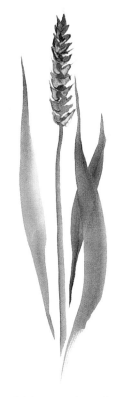

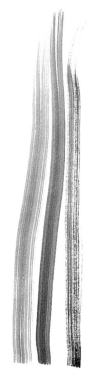

△ The edge of a small flat brush lightly dipped in paint will leave broken lines that resemble grass seeds when repeated in herringbone fashion and linked with fine stems.

△ Paint an ear of corn then scrape or blot out highlights. Use expressive brushwork for the grass itself, varying the thickness. Start with the pointed brush tip then generally increase and decrease pressure, lifting off with a quick flick.

△ To make a multi-coloured stalk, load a flat brush with two colours dipped on to each side of the bristles. It will be a blended or textured line of paint depending on its degree of dampness.

△ A flat brush filled with paint and pressed against the paper will make a solid mark. As you lift it onto the edge, easing the pressure, the drier bristles will leave striations of white paper. Twirl the brush sideways as you move upwards.

project . . . Painting thistledown

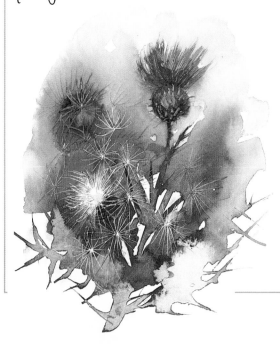

✦ Mask out spidery lines for floating silvery thistledown using a pen and nib.

✦ Mix washes from rich, dark colours such as Purple Madder, Thionindigo Violet, Indanthrene Blue, Sap Green and Vandyke Brown. Paint over the masking fluid, fading the dark washes towards the top.

✦ Paint a thistle tuft with a wet blur of Purple Madder on a pale area and scratch lines with a scalpel. Scrape wedge-shaped marks out of the rounded base of the thistle. Scratch distant thistledown out of the drying paint. These marks will be pale but not as bright white as the paper when you remove the masking fluid.

Fruit

There are two important qualities to remember when painting fruit: their three-dimensional forms and surface finish. Their solid rotundity is largely achieved through shading with paint. It is easiest to describe a round form when there is a strong light source to give tonal changes. The palest area will be where light hits a surface, gradually darkening as the fruit turns into shadow. This can be painted with graded washes or by building up layers.

Of course, fruit is not always spherical or symmetrical; some varieties have lumps, dips, bends and splits. It is these variations that make their shapes so interesting. However, you should not lose sight of the overall form and tonal value when shading these diversions.

Shine

The shiny or glowing surface of fruit will need to be considered while you are shading. It is better to leave white paper in watercolour painting than to use gouache for added shine. The harder the edges and brighter the white of highlights, the glossier your fruit will be. Matt-skinned fruit such as peaches can be shaded to a pale wash without any white left, whereas gleaming apples need soft-edged highlights.

△ This was painted on a Not paper which allowed the graded washes to blend smoothly while leaving crisp edges. Shadows link the fruit with the surface they are resting on and help to emphasize their three-dimensional quality. Some of the colour of the fruit appears in the shadow where it reflects onto the surface.

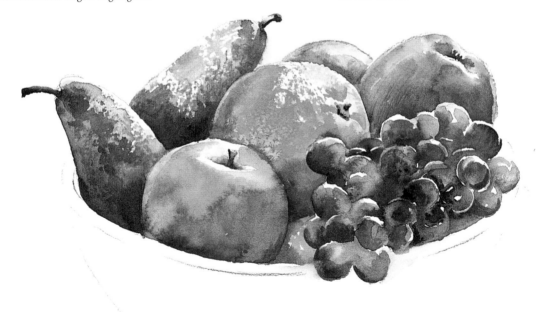

▽ Glossy fruit such as grapes have hard-edged highlights, so leave small sharp patches of white paper within each wash. Where fruit overlap, allow some to merge as well as painting them separately in order to make a cohesive group.

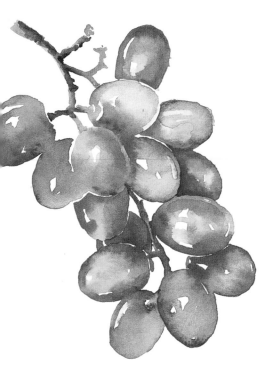

project . . . Painting fruit

✦ Paint some fruit as if they were still growing. Concentrate your efforts on capturing the character of your chosen fruit.

✦ Use colours that echo or complement each other and edge values that describe the quality of the fruit. A painting of peaches, for instance, may have soft velvety paint and pastel colours. One of lemons might be a simple design using tangy colours and sharp edge values.

✦ Introduce leaf shapes into the composition for contrast and pattern.

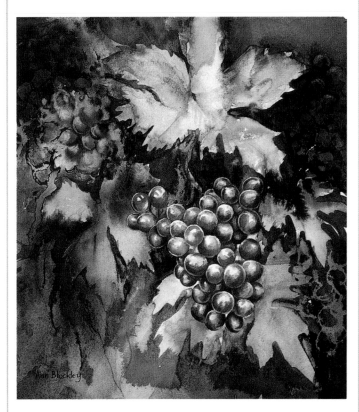

△ **Purple Grapes** *24 x 24 cm (9¹⁄₂ x 9¹⁄₂ in)*
In this painting of purple grapes I tried to introduce an aura of mystery with sinful dark wine colours. The foreground grapes are crisper, rounded and gleaming, beckoning to be plucked. In the background lurk the shadowy ghosts of further fruit.

◁ A group of fruit presents a complex subject with varied shapes, surface textures and colours. The problem is how to unite these elements. It is all too easy to become so involved in individual detail and local colour that the separate fruits do not relate to each other in the finished work. Here they are linked through use of colour, each sharing traces of all the other neighbouring fruit colours. These colour links help to lead the eye from one shape to the next.

demonstration . . . Apples

My intention in this painting was to make the ripe, glossy apples look irresistibly rosy and gleaming against their trellis of green foliage. I set out to create fruit that would practically beg to be picked and eaten straight from the branch. I suggested the crunch and crispness of fresh fruit using plenty of sharp, clean-cut edges. Translucent warm colours evoked luscious juicy flavour.

COLOURS

Cadmium Yellow
Cobalt Blue
French Ultramarine
Green Gold
Perylene Maroon
Quinacridone Gold
Transparent Red Brown
Sepia ink

▽ **Stage 1**

I masked out the apples and some of the leaves – the parts that were to be most detailed – and also the palest sky. Next I painted all the unmasked paper, creating soft flat leaf shapes and background apples as I went along. Working from top to bottom, I used mixtures of all my chosen colours. I introduced hints of Sepia ink for the dark areas.

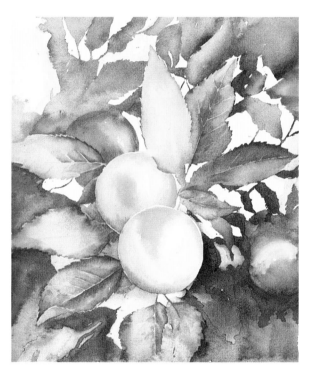

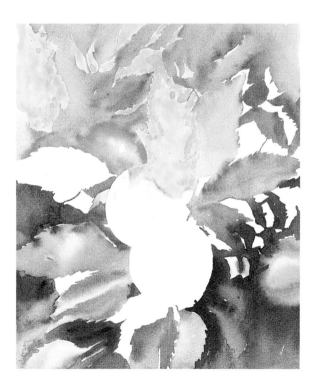

△ **Stage 2**

The next step was to begin filling in the central apples and leaves with pale washes, starting to shade the apples and create some roundness. I softened the white of some of the sky gaps. Veins were introduced into leaves by painting dark washes up to narrow paler lines of the original wash.

▷ Stage 3

The main job left was to complete the apples, building them up with layer upon layer of colour. I was careful to leave white paper for the shiny surface, grading the tone into quite solid paint. The mottled flecks of russet that characterized this variety of apple were feathered in with quite dry paint on a small brush.

▷ Orchard Apples
26.5 x 22 cm (10 ¹⁄₂ x 8 ³⁄₄ in)

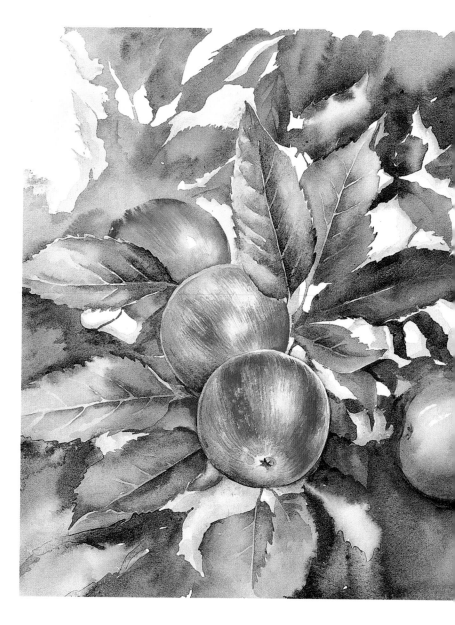

FURTHER IDEAS

Paint a simpler composition of fruit, cropping in quite close so that attention is firmly focused. Try painting on a smooth HP paper so that you can make the fruit highly detailed. Draw it life size so that, depending on the size of your subject, the finished picture will be relatively small.

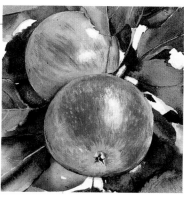

◁ Apples 2
15 x 13.5 cm (6 x 5¹⁄₄ in)

october

October – the magical month of alchemy and treasure trove, when Hallowe'en spells are cast to richly bronze and gild the woodland leaves. The woven tapestry of hedgerow is made precious with glistening gems and rubies, conkers lie gleaming in the grass like polished mahogany and flowerbeds are jewel bright with autumn colour.

Bronzed and brilliant colours

The garden is alight once more with late-flowering annuals in brilliant colours that turn the artist's mind to inks, for a strong and gutsy medium is required to translate these powerful hues. There are pom-pom heads of coppery dahlias and golden whorls of chrysanthemums standing in formal rows while nasturtiums still cascade profusely from pots. Autumn crocus flutter on the ground like weirdly shaped leaves, looking like refugees from another season. Leaves are beginning to change colour and everywhere we look our eyes are caught by the flash of berries. October is the archetypal autumn month.

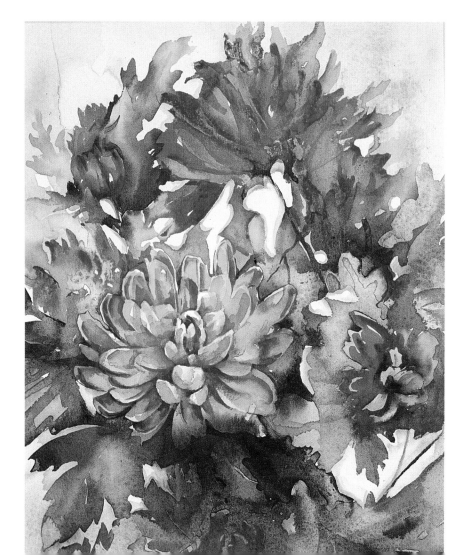

◁ **Chrysanthemum**

29 x 22 cm (11 ¹/₂ x 8 ¹/₂ in)
Chrysanthemums can be rather formal when they are growing in the garden and I prefer the more relaxed shapes they fall into when they are placed casually in a vase. Here I ignored the vase, though, and concentrated on creating a mixture of bright and sombre autumn colours.

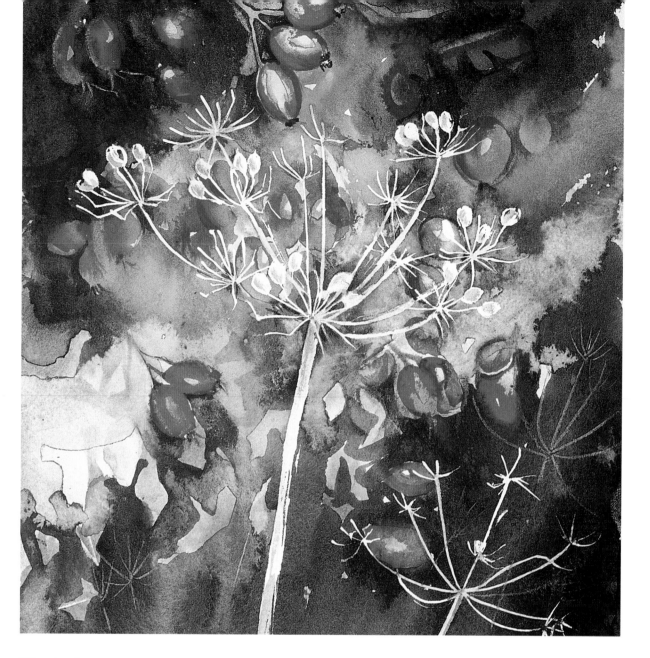

The hedgerow

It is the hedgerow that seems to sum up the spirit of this time of year. It is a happy marriage of berries, hips, nuts and fruit alongside leaves, seeds and tangled twigs. There is an abundance of opportunities for examining all these subjects, both separately or grouped together. Every part of a hedge offers a new intricate composition that can be enjoyed for its abstract textures, patterns and colours.

If you plan to paint a complete picture of such subjects, be careful to find a focal point for the eye to rest upon unless you deliberately intend to create a decorative, busy pattern. The clean-cut starry trumpets of white bindweed would make a refreshing floral contrast, or a plant skeleton such as a teazel or some grasses would provide a focus. You could centralize a group of large leaves or let a butterfly rest on a patch of brambles. Alternatively, one or two stems of cuckoo pint or lords and ladies would make an eye-catching centrepiece with their clusters of scarlet berries. These are just a few ideas as a starting point; the variations are endless.

△ **Autumn Berries**
22 x 17.5 cm (8¹⁄₂ x 7 in)
I wanted to avoid creating just an overall pattern with these rose hips, so I added a hogweed stem as a focal point. This enabled me to treat some of the hips as background impressions. I simply dropped touches of red paint into the initial washes and sharpened their shapes up later where needed.

Berries

Berries offer plenty of variation in colour and form and it would be a mistake to think of them as invariably red and round. They often are, but the reds come in many different hues from orange to purple and the roundness might be oval, elongated or squashed. They may vary in colour as they ripen, so that within a species such as bryony they can be found in a range of colour from olive to yellow, gold and crimson. The calyx might be a small, neat star shape or reach out in long curling tendrils, or it may have shrivelled away completely.

It is easy to get the size of berries wrong in the context of a complete picture. Compare them with another part of the scene such as a leaf or late flower, judging how many times one berry fits into the other object to get an idea of proportion. For example, a blackthorn leaf is roughly one and-a-half sloes long but there are nearly three haws to a hawthorn leaf.

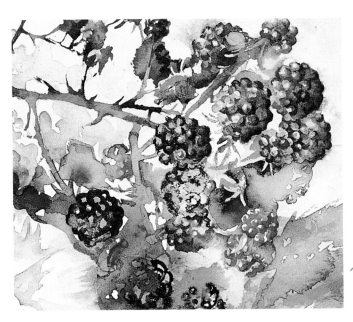

△ **Blackberries (detail)**
In spite of their name, black paint is not suitable for blackberries as it can have a deadening effect. Combinations of rich or dark colours such as Purple Madder or Alizarin Crimson with Indanthrene Blue or Payne's Grey will give a much more convincing representation of their juicy ripeness. Although these berries are dark, concentrated shapes, you can also paint pale versions to make them recede.

project . . .
Looking at autumn fruits

✦ Go for a walk and look at all the different berries, hips and haws in the hedgerows, woods and gardens.

✦ Ask yourself a series of questions about their appearance and think how you might paint them. Is their shine mirror-like or dull? Do they hang in clusters or singly? Do they hug the stem? Are their stems thick, slender, hairy, rough or smooth? Are they hard or soft?

✦ Gather a selection of species to study at greater length at home.

✦ Decide on the most important features of each different species and emphasize these points in your subsequent paintings.

△ It is the contrasting shapes that gives these rose hips their individuality; the slightly flattened plumpness of the hips is set against the spidery, angular calyx.

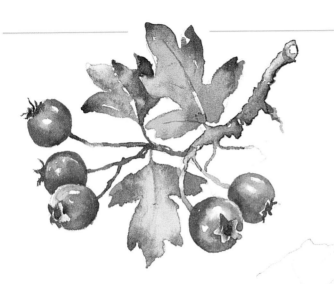

◁ I used Alizarin Crimson and Purple Madder for the dark red haws. They have a dull sheen with small, soft highlights.

▽ I love seeing the long necklace strands of bryony festooning the hedges. They have slight dips at their base just like the holes in beads, and a half moon highlight accentuates this.

▽ I created stylized blackberries using the washing out technique. Photo realism is great but it is sometimes more exciting (and quicker!) to find different ways of encapsulating an idea.

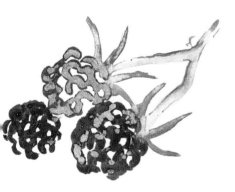

▷ I used scarlet ink for ruby red rosehips and exaggerated the crisp white highlights for a stark, graphic interpretation.

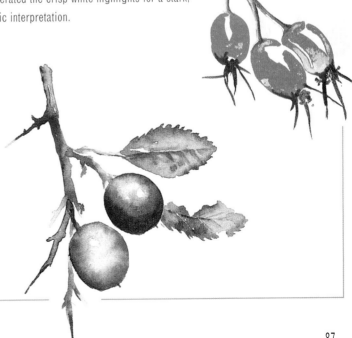

▷ To create a shiny sloe I painted an oval of dark colour, allowed it to dry then lifted out highlights by dampening and blotting out some of the paint. Early sloes have a smoky, blue bloom. To describe this powdery deposit I felt justified in dusting a hint of white gouache over a completed sloe.

Using acrylic inks

Acrylic inks are powerful pigments and are therefore an ideal medium for enriching a lively autumn colour scheme. I began using them in conjunction with watercolour at a time when I became frustrated by the pale appearance of some of my paintings. Sometimes I wanted to achieve a stronger, darker look but without losing the freshness. Watercolour, for all its wonderful qualities, can be sulky and temperamental and will easily turn to mud if made to work too hard.

▽ This selection of transparent colours provides a useful range for the flower painter. From left to right: Sepia, Burnt Umber, Flame Red, Process Magenta, Flame Orange, Indian Yellow, Process Yellow, Indigo, Prussian Blue.

Acrylic artist's inks are water-based, which means they can be mixed with water. Look for transparent colours and avoid the ones labelled 'opaque'. Most importantly, they must be permanent or lightfast; the brilliantly coloured ones designed for graphic art and reproduction purposes will fade when exposed to sunlight, which could be disastrous.

Apart from the strength of colour, the important difference between ink and watercolour is that being acrylic the inks are waterproof. Once they are dry on the paper they cannot be lifted or smudged as watercolour can.

How to use inks

Inks can be used in the same way as watercolours for painting washes, taken straight from the pot for sizzling depths of colour or diluted in a palette. Sometimes I drip small amounts directly on to a wet wash, using the pipette in the lid. I also mix rich colours on the palette, combining two inks or mixing one with some ready diluted watercolour – the two mediums are compatible.

Before you begin, think carefully about whether to use inks at all in your particular painting. Does it really need it? Can you achieve what you want with your usual paints? As a rule of thumb, restrict inks to strong tonal areas or small amounts of bright highlights.

▽ **Chrysanthemums (detail)**
The vibrancy of the inks in these petals is intensified by the dazzling white background surrounding them. This was achieved by blocking out the negative shapes with masking fluid and letting inks and watercolour flood together within the flower.

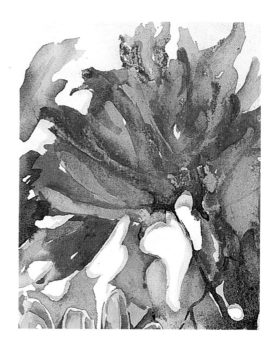

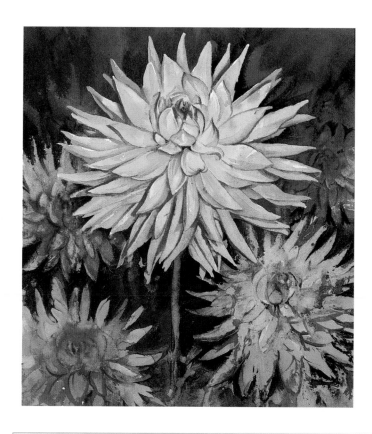

◁ **Dahlias**

33 x 28 cm (13 x 11 in)

The very strong tonal contrasts in the background of this picture were made possible by combining inks with some warm watercolour pigment. The crisp edges caused by the ink's quick-drying time are appropriate for the formal dahlia petals.

project . . . Painting layers of petals

✦ The complicated pompom structures of flowers with multi-layered petals such as dahlias and chrysanthemums are quite daunting. The task is to simplify these shapes without losing their character.

✦ If you prefer a detailed style, concentrate your efforts on the front of the flower and let petals at the back fall away with less detail.

✦ If you decide to paint loosely, a few irregular petal shapes around the perimeter of the flower may suffice, with a hint of a centre and some brushstrokes to suggest further petal swirls.

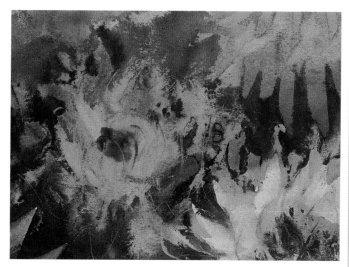

△ Chrysanthemums are constructed from architectural layers of petals. Abstract marks only hint at the chrysanthemum's identity but are sufficient to create an impression of petal layers.

demonstration . . . Hawthorn

If a hedge were to be sectioned into rectangles, each one would offer a unique composition of patterns and shape. A hawthorn hedge offers pleasing contrasts, with geometric triangles of sky peeping through gaps between zigzagging leaves and rounded berries.

COLOURS

Alizarin Crimson
Burnt Umber
Cadmium Red Deep
Phthalo Blue
Quinacridone Gold

▽ **Stage 2**

Making several washes of gold, brown and green in various combinations, I painted over the leaf areas. I allowed colours to vary within the leaves, defined some of the jagged edges and let others merge. The berries were painted with Alizarin Crimson, with their edges allowed to diffuse into the damp background. When the paint was dry I removed the masking fluid to reveal crisp shapes.

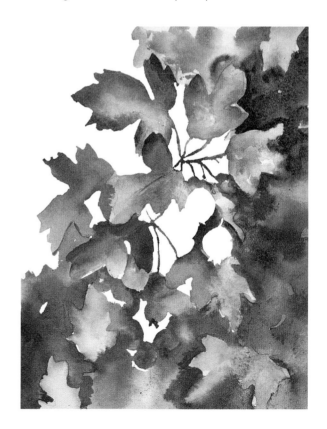

△ **Stage 1**

As I drew a pattern of leaves and berries I was mindful of the negative spaces between, which were to be as much a feature as the hawthorn itself. I masked these gaps as well as some of the central berries.

▷ Stage 3

I painted in the central berries, concentrating on their roundness and shine. The dark tones were made from Alizarin Crimson mixed with a touch of Phthalo Blue and then a little Cadmium Red Deep for brightness. Where the background seemed woolly I crispened it up with a few more leaves and darkened or added detail when necessary. I finished off by toning down the white sky with a very pale wash of Quinacridone Gold toned down with Burnt Umber.

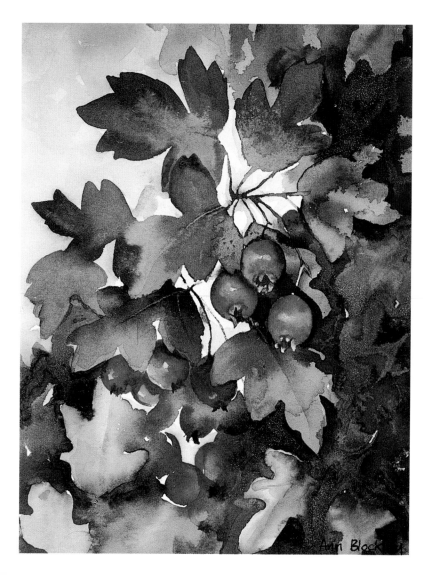

▷ Hedgerow Hawthorn

22 x 16 cm (8³⁄₄ x 6¹⁄₄ in)

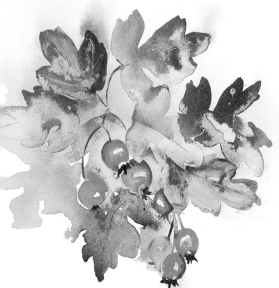

FURTHER IDEAS

Quickly paint some more hedgerow leaves and berries, using inks and thick, creamy watercolour. Leave for a minute or two but watch carefully that it does not dry completely. Pour water from a jug over sections of the vignette and wash away parts of the ink and paint. The result should be a variety of hard and soft edges and marks.

november

Colours blaze in a finale of firework intensity. Dahlias form Catherine-wheel spirals and seedheads of allium flicker like Guy Fawkes sparklers. Travellers' joy curls and winds through hedges like a veil of wood smoke. Flaming leaves swirl and flutter a last flamenco. Finally, the bonfire colours extinguish, leaving charcoal greys and the smouldering ashen tones of late November.

The changing season

November is a month of dual personality. The early weeks belong to autumn, when the trees are all changing colour quickly then shedding their leaves. They whirl and fly to the ground where they lie in fabulous carpet designs. Suddenly, the last leaf is wrenched from its bough and we are plunged from glorious Technicolor into the monochrome of early winter. The clouds are grey, it is muddy underfoot and the garden is drab.

▽ **Honesty**
29 x 24 cm (11½ x 9½ in)
Honesty is a joy to paint in autumn. The seedcases are mottled and opaque but peel away, scattering seeds to reveal translucent silvery discs of paper.

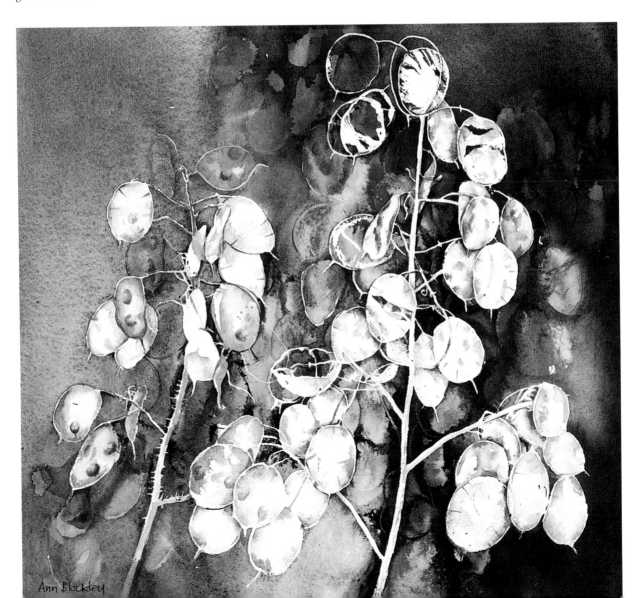

Ann Blackley

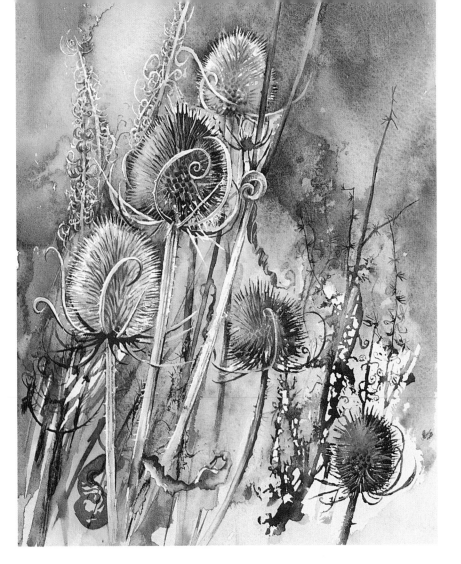

◁ **Teazels**

28 x 20 cm (11 x 8 in)
These teazels were gathered from the garden and put in containers. Although they were painted in the comfort of my studio I made the finished picture look like an outdoor scene. I relied on my memory for ideas about atmosphere and background but had the teazels in front of me for botanical details. As I wanted to evoke the air of late autumn I included a series of warm, golden colours. I made some of the teazels pale against a darker background. Portraying them as dark silhouettes would create a classic wintry image, an idea I stored away for the future.

At this time of year when the autumn pyrotechnics are over we have to shake ourselves and hunt further for painting ideas. Our eyes have become lazy after months of plenty. We need to re-educate our vision to appreciate subtleties and to feast on simple pleasures such as the last solitary rose hip lending a nostalgic air to a sepia-tinted tangle of twigs; a tiny bright leaf or pheasant feather trapped in a mesh of stalks creating geometry and contrast; butter-yellow winter jasmine hugging the warmth of a cottage wall; or chandeliers of raindrops glittering from a fretwork of ferns.

Gathering information

The spiky heads of teazels are a reminder to squirrel away nuts, pine cones, husks, empty pods and twigs. This supply of texture and form will feed any hunger for subjects which can be painted in the house as gloomy weather descends. Handfuls of foliage, either still colourful or twisted and shredded into fantastic abstract shapes, can be gathered and put to use indoors to re-create the scenes observed outside.

In your studio or on a spare table you can use artistic licence to combine real-life observations of your harvested plants with ideas from your imagination or from quick sketches snatched on the spot. Such paintings can stretch your creativity to its very limits.

Autumn leaf textures

I find the fiery colours of autumn trees enormously striking. As an artist it is the close-up details of the individual leaves that I find really exciting. Each is a miniature map with markings and lines for the eye to travel along and explore. The patterns of the veins and the marblings, blotches and speckles of colour make wonderful designs. Their interest is increased still further when the leaves begin to break down and tear to give crumbling edges and ragged holes or as they curl and twist themselves into three-dimensional forms.

It is good practice to paint different leaf types, matching the markings of each variety with paint effects. Look also at their shapes and pay attention to qualities of their edges; some have smooth, scalloped curves, while others are notched and nicked. Surface textures vary from smooth and glossy to matt and brittle. Some leaves are solid; others are almost transparent.

As you crunch through piles of rustling leaves on your walks, look out also for nuts and seeds. Collect conkers and acorns; they are a rich source of texture.

△ Hint at the spinning, twirling movement of maple keys by painting stems in flowing flourishes of the brush. Echo these curves with further loose line work and keep edges feathery and open rather than confining them within a controlled space.

◁ Oak leaves often have a mottled surface which is accentuated by the lumps and bumps of the leaf material itself. To paint them you could use granulation medium or salt sprinkled into a damp wash. You could also spatter in dots of muted colour or plain water to form pockmarks.

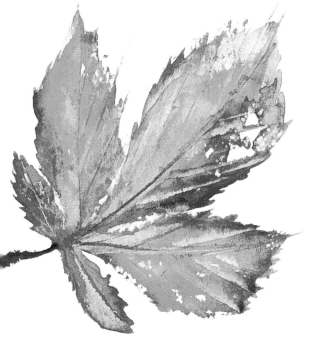

◁ Horse chestnut leaves begin to split and crumble quite early in the season. This brittle, frail quality can be described by scratching and scraping holes within the leaves and at the edges. Small white holes can be made by using a spattering of masking fluid before applying the wash.

△ Paint the ridged surface of acorns using parallel lines of paint. Leave tiny white linear gaps between brushstrokes for highlights. Create the rough cups by dabbing small dots of colour in various tones with the point of a small brush.

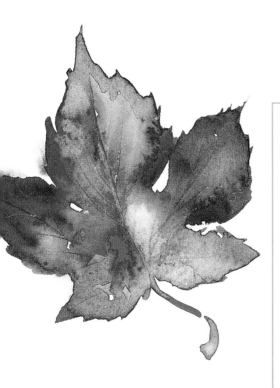

project . . . An autumnal still life

✦ Bring autumn nuts, leaves and seeds indoors to create a still life. Do not mix a too diverse selection of items; choose simple, natural combinations such as acorns with oak leaves or cobnuts with hazel leaves.

✦ Drop your goodies on to a surface and allow them to arrange themselves as they would in nature. This way you will avoid an artificial-looking composition. You could use a long, landscape format appropriate to the theme of this ground-hugging subject.

✦ Cheat a little and pretend that you are still outdoors by inventing a grassy or earthy surface. Alternatively, spread out enough overlapping leaves to create a leafy carpet under your focal point of nuts or seeds.

▽ Horse Chestnuts (detail)

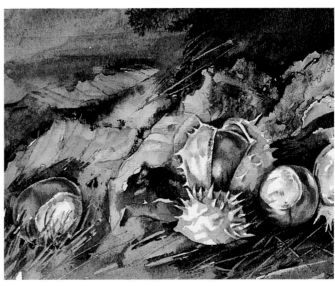

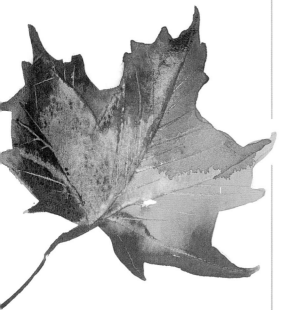

△ On one of these maple leaves water was brushed into a wash to create pale, cloudy markings that evoked a soft sheen. On the other leaf slabs of colour were scraped off with the flat edge of some cardboard pieces to make hard reflections. Where the veins caught the light they were scratched out with a scalpel.

demonstration . . . Autumn leaves

My aim here was to record a classic scene of fiery autumn colour. I am equally fascinated by the patterns made by leaves whether they are still on a tree or are lying underneath in blazing carpets. For this picture I chose to show that moment where some were still clinging and others were just beginning their descent. I combined a soft background blur of wet-into-wet colours with crisp, attention-seeking leaf edges.

COLOURS

Burnt Umber
Cadmium Red
Cadmium Yellow
French Ultramarine
Green Gold
Purple Madder
Transparent Red Brown
Yellow Ochre
Indian Yellow ink
Sepia ink

△ **Stage 1**
I drew a pattern of leaves, angling them in the same direction. Next I dampened the paper with water and painted variegated washes over it, ignoring the leaf outlines in places and sometimes containing the paint approximately within the shapes.

▽ **Stage 2**
Once the washes were dry I applied dark colour over parts of the background to make pale leaves and maple keys emerge from the wash. The darker paint was kept crisp around the leaves but was blended smoothly back into the background.

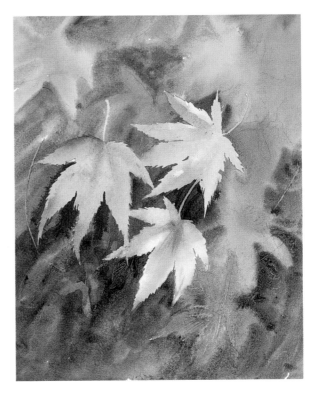

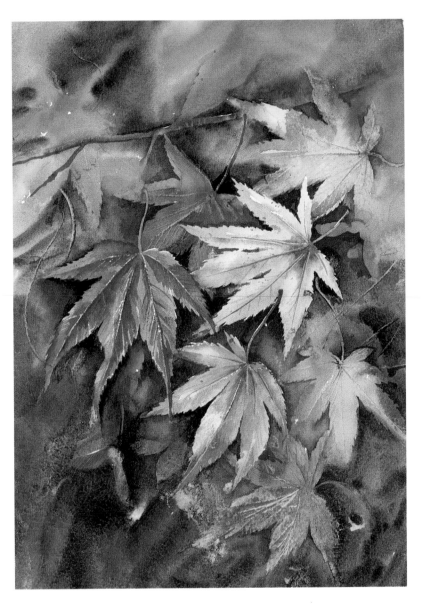

◁ Stage 3

I continued making new leaves appear but did not define every edge as before. To retain focus on the main leaves I made them more vibrant and detailed, varying each in tone and colour for interest. Finally, a simple branch was added to hint at a tree without making a statement of it.

◁ **Autumn Leaf Patterns**
32 x 26 cm (12½ x 10¼ in)

FURTHER IDEAS

Now paint falling leaves, working quickly and freely to concentrate on their swirling, floating movements. Detail and hard edges pinion a subject to the page, whereas a loose, blurred style allows foliage or petals the apparent freedom to flutter and dance in the gusty breezes of autumn.

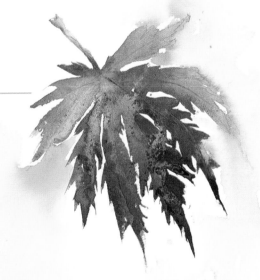

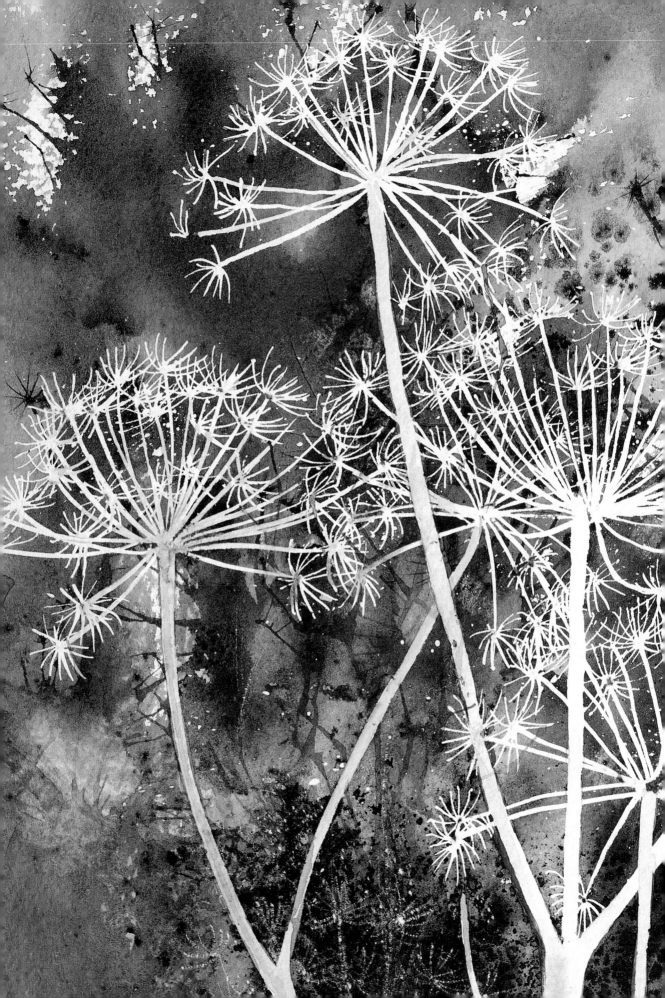

Winter

december january february

Stark, graphic images and brittle texture; colours bleached to tones of faded sepia; silhouettes and skeletal branches bristling with frost. Winter has arrived. Mist and snow muffle sound and blanket the landscape. Simple pleasures become a feast: the solitary flash of a scarlet rosehip; the creamy wax of the Christmas rose; and snowdrops piercing the frozen ground, gleaming pearls of hope for the year ahead.

Winter Hogweed
28 x 40 cm (11 x 15³/₄ in)

december

By December colours have faded and are restricted to shades of monochrome, so this month tonal values are tremendously important. Now that bare bones of stalks and branches are revealed the look is stark and graphic. Plants are either dark and dramatic against pale, silvery skies or white and glamorous, furred with glittering frost.

Subtle and sophisticated colours

Images veer from the sensitive subtleties of white on white to the drama of black and silver. Occasional brilliant flashes of hue in winter berries or coloured stems add to the dramatic scene. Colour may unexpectedly reveal itself on bright days when a low sun finds gold highlights in a brown teazel or fluorescent speckles of lichen cheer up a dull hedge. The blazing coppers and bronzes of autumn have gone but in their place is the cool, sophisticated sheen of polished steel, pewter and zinc.

▽ **Snowy Holly**
22 x 22 cm (8¹⁄₂ x 8¹⁄₂ in)
This picture is full of contrasts, with the sharp edges of the holly against the soft snow; the rough and the smooth; and the dark leaves and bright white snow.

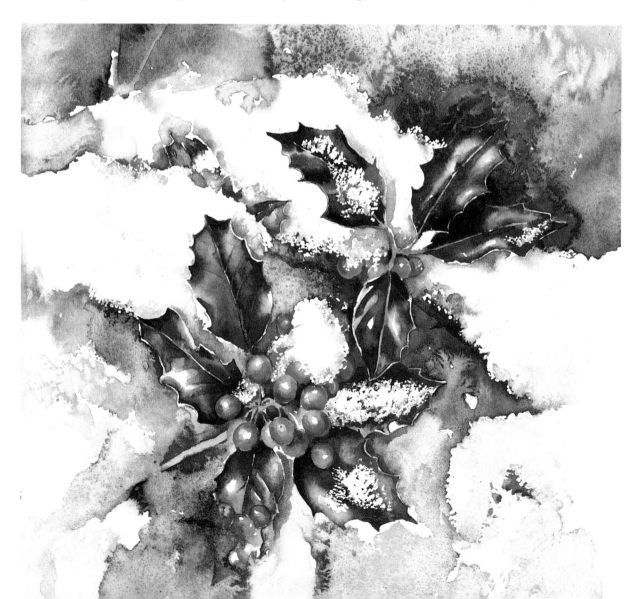

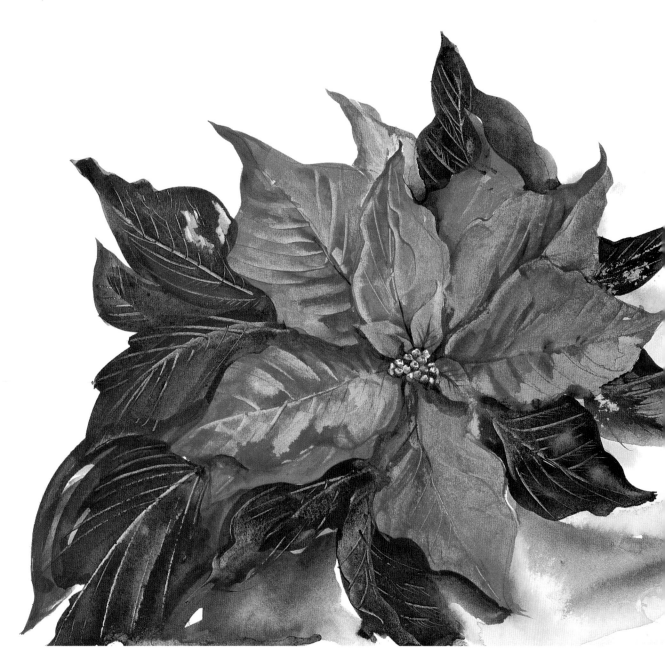

△ Poinsettia

26 x 30 cm (10¹/₄ x 11³/₄ in)
I painted generous brushstrokes
of thick paint in shades of red
and green then used a scalpel to
scrape and scratch the leaf
shapes and veins of the poinsettia.

Evergreens

Evergreens play an important role in colouring the winter landscape. Rich viridian greens, smoky blues and dazzling variegated leaves largely replace flowers this month. You may not have time for much painting over the festive season, but if you do find a space some pictures of evergreens would be a good way of celebrating. Plants such as holly, ivy, yew and mistletoe are used at Christmas to adorn our homes and with their colourful berries and graphic shapes they are ideal for designs and decorative work. The festive reds and greens of leaf and berry can be emphasized to paint sprigs or borders.

Still lifes of Christmas hyacinths in woven baskets or copper pots full of colourful hothouse flowers are another option, combined with pine cones, ribbons and fruit and placed on surfaces draped richly with velvet or damask. You can make copies of your paintings and send them as special personal Christmas or seasonal cards.

Winter skeletons

By wintertime petals and leaves have been stripped bare to reveal the basic skeletons of plant forms. The linear forms of stalks, branches and spent structures are clearly visible and it is now possible to see their growth habits properly, from the graceful and arching to the tortuous or straight. The details of their surfaces are no longer camouflaged. Some have smooth, shiny or velvety skins, others are covered in gnarled, rough bark. There may be bristles, hairs or jagged shark's fin thorns sticking out along their length.

▽ Criss-crossing branches make superb geometric designs with square or triangular negative shapes. Thorns and smaller stems thrust out at varied angles. Look out for the tonal patterns where light twigs cross over dark ones and vice versa.

▷ Hogweed can be rather symmetrical but these broken stalks and overlapping shapes created an interesting asymmetry. I softened the rigidity of the pen and ink used to draw this by adding cobweb strands and spattering ink with a toothbrush and lightly smudging it.

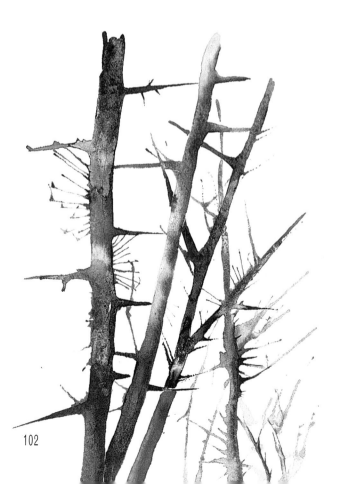

△ This abstract observation is a spontaneous response to a theme of tangled hedge and undergrowth. I painted loose lines of paint then gently blew the gathered pools of liquid to send pigment shooting out in unexpected directions. I dragged out tiny blobs of paint with a sharp point into finer lines.

With very little colour to distract the eye, interest is focused upon the abstract tonal patterns of overlapping and interacting lines and shapes. Without the softening curves of flowers, the emphasis now is on sharp, taut angles. When brittle dead stems snap and splinter, the geometric effect is increased even further.

Silhouettes

The bare bones of winter plants are often seen as silhouettes, dark and dramatic against pale sky, snow or mist. If you want to paint a subject in silhouette you may need to change your eye-level in order to view it against a bright light source. Outside you can bend down to look up at plants and inside you can re-create the effect by raising the subject up on a pile of books or a similar device. If there is no suitable window or light source you can improvise by placing a sheet of white paper behind it. Alternatively, you can set up a negative image, the reverse of the silhouette, by placing a light-coloured subject such as honesty in front of a dark background.

project . . . Printing

✦ Find some flat wintry plant shapes such as honesty, ivy or leaf skeletons. They should be quite flexible and not too solid.

✦ Gently squash flat any bits that stick out, such as stems or extra leaves. Paint over the whole of one surface with watercolour or ink, paying particular attention to the edges.

✦ Lay a sheet of smooth paper on top of the painted surface and, being careful not to smudge it, press down firmly. Use the flat of your hand or a rolling pin to smooth over the whole area thoroughly.

✦ When you lift the paper you should have a printed impression of your subject. You can leave it as it is or add extra detail or background.

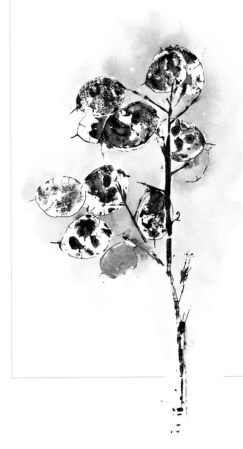

Wintry backgrounds

Winter is a time when backgrounds become especially important. Plants and flowers are stark, simple and often skeletal. They may be a striking focal point, but it is the texture and subtle colours behind that add mystery and atmosphere. The mood of the weather dictates the most suitable technique. Dappled rain, swirls of mist, the slashing of wind or flurries of snow all require individual treatment. Texture-making techniques such as blotting out, sponging colour on, dripping water into a drying wash or wax resist may all be useful. You may like to try adding shimmery inks to give a pearlescent sheen to your work.

Tonal values need careful consideration when you paint a wintry scene. There are two strong images that spring to mind. The first is the drama of bright white frosted plants and grasses standing out in stark relief against the dark backdrop of blackened hedgerow or heavy evergreen. For this you would need to use strong, dark paint, even adding black Indian ink to make a powerful background behind masked-out shapes.

Secondly, there are the pale, ghostly images of white on white, when sensitive decisions regarding tonal value need to be made. It is vital to keep pale tones clean and use dazzling blue shadows rather than a dirty grey or dilute black.

Detergent

A wonderful effect can be made by putting a tiny amount of detergent into diluted watercolour, adding enough water to create bubbles rather than just froth. This works best on a smooth

△ **Frosty Rosehips**
15 x 13 cm (6 x 5 in)
I dabbed masking fluid with the point of a rubber shaper onto the hips and stems to create a dredging of hoar frost. Salt scattered into a damp background wash conjures up the effect of winter weather.

◁ Adding detergent to dilute watercolour creates bubbles that pop as the paint dries and either forms dark dots or pale circles rimmed with darker lines of paint. This is ideal for wintry background effects.

surface. The mixture is painted on to the paper as normal, the bubbles following the directions of the brushstrokes to give a vigorous sense of movement. By varying your style of brushwork you can create different moods and impressions of weather. Random swirls seem like fluttering snowfall, whereas a series of parallel brush lines creates driving rain. As the paint dries the bubbles pop and either form dark dots or pale circles rimmed with darker lines of paint.

Salt

Salt sprinkled into wet paint also creates textures that are perfect for describing icy or snowy backgrounds. The salt crystals either slowly dissolve into the drying paint or absorb the wet paint, producing pale starry marks that are highly reminiscent of snowflakes. By experimenting with different dilutions of paint and varying the amounts of salt used you can achieve a range of textures. Table salt creates a more overall, random effect than larger lumps of sea salt, which can be distributed accurately and sparsely.

△ This shows the marks that can be made by adding salt to a wash. The most dramatic results occur when the paint is medium in tone and consistency.

project . . . Making a snowy scene

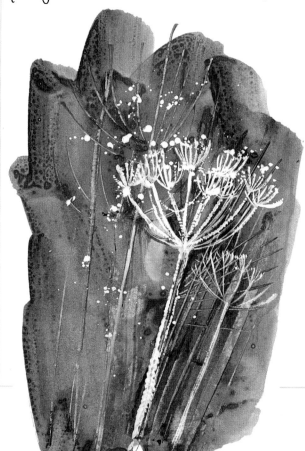

◆ Select a smooth white paper on which to paint a textured background wash, using cool colours such as French Ultramarine, Cobalt Blue or Viridian. A dark background is needed to show up frosty white forms. Try the bubble technique, salt or any other evocative method.

◆ Scrape out a few frosty hogweed stems or grasses with a sharp edge while the paint is damp.

◆ When the background is dry, use white gouache on top to paint a snowy focal point. Keep the paint creamy and opaque. Splatter some blobs to add a drifting of snowflakes to finish the scene.

◁ Quick, atmospheric snow scenes such as this little sketchy picture are effective and fun.

demonstration . . . Winter roses

The pure white petals of the Christmas rose dazzle like angel wings, with a golden star shining from each flower centre. The shimmer of silvery grey and gleam of gold is a festive and decorative theme with which to finish the year.

COLOURS

Burnt Sienna
Burnt Umber
Cadmium Yellow
French Ultramarine

◁ **Stage 1**

I began by blocking out a group of flowerheads with masking fluid. Once it was dry I dampened the background and painted wet-into-wet washes of Burnt Umber, French Ultramarine and Burnt Sienna in various combinations over the whole area. When these were dry I peeled away the masking fluid and drew in the detail of the flower petals and shadows.

▷ **Stage 2**

Next I pulled negative and positive leaves and stems out of the background, leaving them as simple shapes with little detail. I dampened an area of background in the shape of a young flower and blotted out paint to make a shadowy bud. Beginning work on one of the flowers, I drifted a wash of Cadmium Yellow onto the centre and painted the complicated shadows cast by the stamens with a flat wash of diluted bluey-grey background colour.

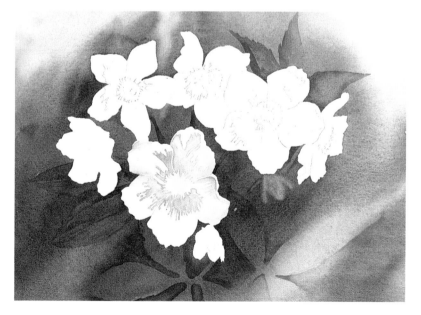

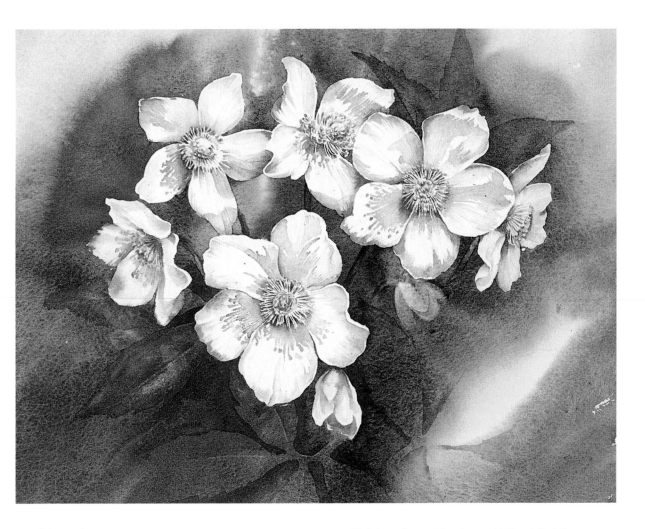

△ **Stage 3**

I put detail into the centres to emphasize them. The shadow colours were used to darken some of the edges and define overlapping petals. The other flowers were similarly painted. Some petal edges were softened or darkened to make them sink back. I added detail to the bud and flower centres.

FURTHER IDEAS

Design a Christmas card using an eye-catching graphic motif. Shown here is a Christmas rose with its centre highlighted in gold ink, but an early snowdrop, an ivy leaf or holly sprig are just some of many seasonal alternatives you could choose. Be highly selective and aim for stark simplicity.

△ **Christmas Roses** *29 x 36 cm (11¹/₂ x 14¹/₄ in)*

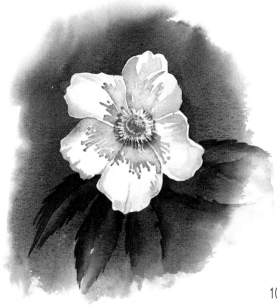

january

As the new year begins we are filled with resolutions to improve mind and body. A good start is to go outdoors and look for subjects to paint; a walk not only gives exercise but feeds the soul with glimpses of new flowers and young shoots. Tender snowdrops pierce the frozen ground, hellebores bow their heads and winter aconites lift our spirits.

Alternative methods

Some watercolourists frown on the use of gouache, but my view is that a painter should be free to decide which rules are to be followed or ignored. In my own watercolours I do not use much gouache, but this is only a personal preference. You may decide that this month is an ideal time to start using this medium. Evergreens and winter flowers are often solid, thick and waxy in appearance, and the skimmed-milk consistency of dilute watercolour that you used for the flimsy transparent

▽ **Winter Jasmine**

16.5 x 20.5 cm (6 ½ x 8 in)
Strong diagonals add drama and movement. The sweeping diagonal stems of the winter jasmine liven up this composition of otherwise small, repetitive flower shapes.

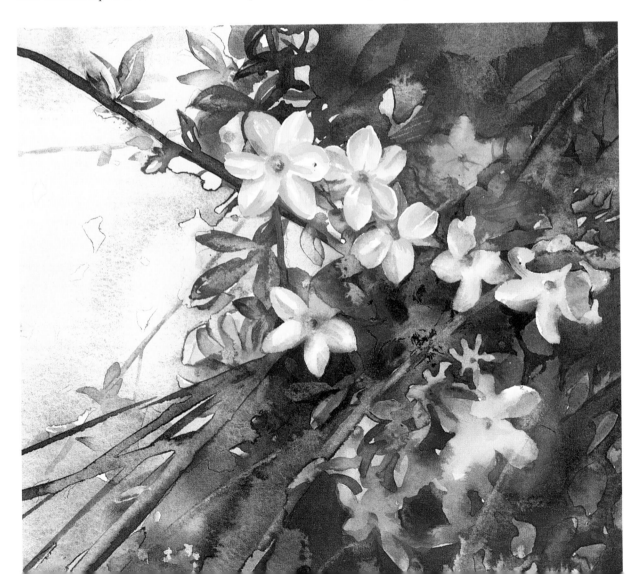

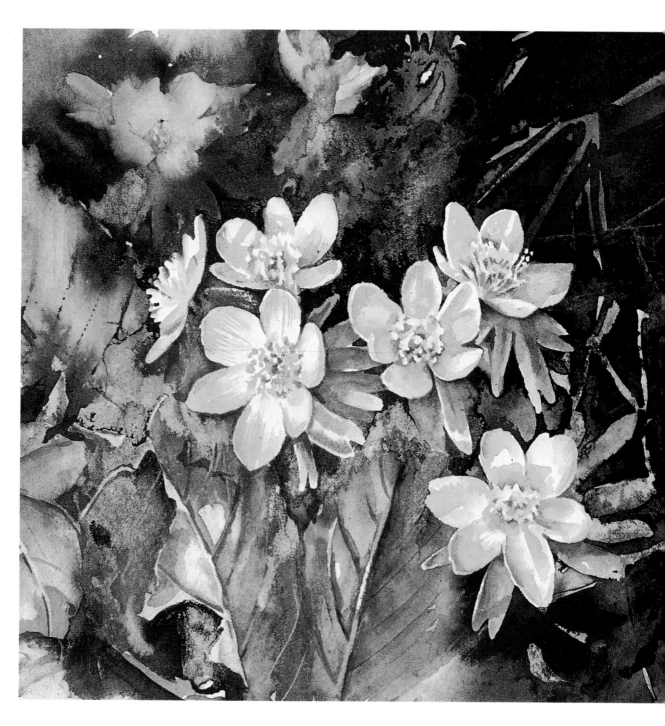

△ **Winter Aconites**
18 x 18 cm (7 x 7 in)
The young, new flowers of winter aconites erupt from old, spent leaves, their pale scalloped shapes outshining the dark, sombre backdrop of angular twigs and broken edges.

petals of summer flowers may no longer be appropriate. Now you need rich, creamy paint and gouache could well be a suitable choice.

The use of photography is another subject for fierce debate. Some regard it as a somewhat inferior way of working or even as cheating. True artists must apparently only work from life. It is certainly important to do so, but somewhat restricting for a flower painter in wintry January. My own opinion is that a bad or good painter will remain so whatever he or she uses as reference and any feelings of guilt should therefore be discarded.

Using photographs

In winter it is often too cold and miserable to work outside and although there is usually something to paint, the pickings are thin and will not always suit your mood. In the warmer months, however, the glut of flowers ensures that even the busiest painter is overwhelmed with possible subject matter and the camera becomes a vital tool. In the time it would take even to sketch a dozen flowers you can click through several reels of film which will provide an invaluable source of visual information in winter.

A photographic image can be an inspiring form of reference when you have taken the picture yourself. The camera has recorded the detailed facts needed for a closely observed painting, but your memory will supplement this with other information such as the weather, surroundings and atmosphere. For this reason, I do not like using other people's camerawork as the resulting painting could not be totally personal.

Adapting the image

It is important to be aware that photographs can be misleading. They can falsify colour and tone, and overlapping shapes may appear to merge together in mysterious ways so that a flower with six petals may appear to have eight or leaves may seem to grow in weird directions. Colour can become very contrasty so that information is lost in areas stained almost black or bleached out by strong light. In your painted version you will have to compensate for this by adding the lost details, lightening strong tones and darkening pale ones. Do not always rely solely on photographs but use other information from observations either memorized, sketched or noted down in words.

Because a printed image is being used the temptation is to try to match it as closely as possible. In fact, the photograph should just provide the starting point for your individual interpretation. It is the role of the artist to simplify, adapt and personalize a subject whatever the source of reference, and there is nothing to stop you departing quite radically from it if you choose. Ugly backgrounds can be eliminated and awkward compositions adjusted; flowers that the camera has chopped in half can be completed or pruned out altogether. By the time you have combined images of different flower types, redesigned the colour scheme and background of the reference prints and used a little imagination the result should be a totally original painting.

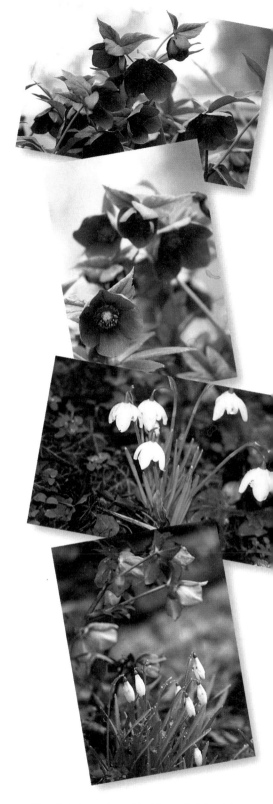

△ When I photograph a subject I usually take pictures from a range of angles including close-ups of flowers, leaves or interesting details. Later I can pick and choose the best bits and compile my own version like a police photofit.

project . . . Painting from photographs

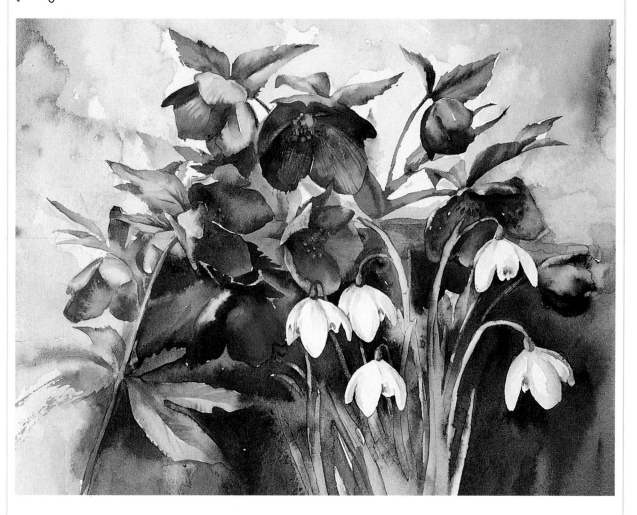

△ **Hellebores and Snowdrops** *25 x 27 cm (9³⁄₄ x 10¹⁄₂ in)*

✦ Choose a series of photographs on a related theme. They must make a natural combination of plants that would normally flower at similar times and in the same habitat.

✦ Pick elements from different photographs that will combine to make the new composition. Use a maximum of four images to keep it simple.

✦ Remember to enlarge or reduce certain elements to keep them in proportion. You may need to invent new elements to link everything.

✦ Choose a palette of colours that will unite the whole picture. These may be either from your imagination or from the photographs.

✦ When you paint the different flowers you may need to adjust the tonal values so that shadows and light source are the same throughout the composition.

demonstration . . . Snowdrops

Using a photograph of snowdrops for reference, I experimented with backgrounds to see how I could change the atmosphere using decorative colours and techniques.

COLOURS

Burnt Umber
French Ultramarine
Indian Yellow
Gold ink

◁ Stage 1

I began by drawing the snowdrops with a pencil. When I photographed them I paid particular attention to framing them in a pleasing zigzag pattern and I decided to follow this composition quite closely. If I had not already designed my painting through the eye of the camera I would have adjusted the drawing until I was satisfied with it. I filled in the pencil-lined shapes with masking fluid.

▷ Stage 2

I brushed variegated washes of French Ultramarine, both on its own and mixed with the other colours, across the whole picture. While it was still wet I flicked gold paint with a palette knife to create a decorative background. When it was dry I added to the texture with more palette knife flickings of French Ultramarine.

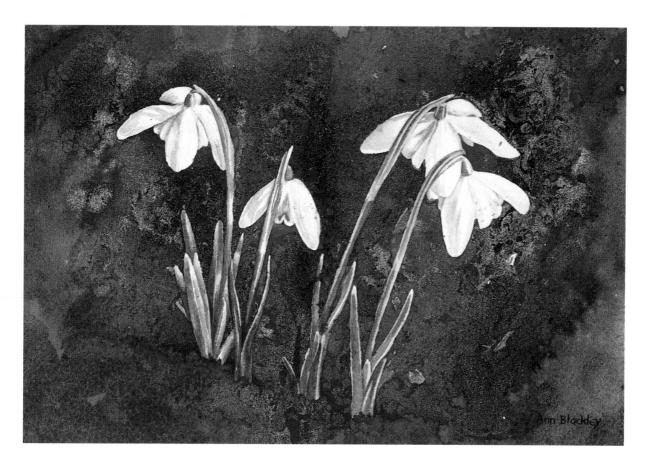

Stage 3

After peeling off the masking fluid I painted the snowdrops. I followed the photograph for information on shading but adapted the colours to suit the background. I painted darker tones where the stems emerged from the ground but otherwise left the backdrop as an abstract, decorative texture.

△ **Snowdrops** *22 x 28 cm (8½ x 11 in)*

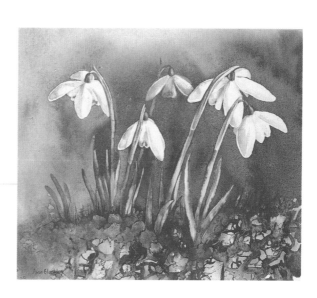

FURTHER IDEAS

Paint another version of the same group with a different background. Take the idea from the photograph of a stony ground and use a range of earthy colours. Create mottled textures with irregular markings to suggest soil and pebbles.

february

Dull, dun February when gardens are bare and forlorn. Ignore the gloom of the view and huddle indoors with intimate still life subjects. Bask in the bright glow of florists' flowers. Then, as your spirits lift, confront the bleak outdoors. Kick aside old leaves to discover that all is not grey. Brave patches of gold are pushing through the sad winter debris; spring is waiting in the wings.

Banishing gloom

February can be a depressing month. The winter seems never-ending, the weather is dreary and self-motivation can be difficult. However, in the same way that you can cheer yourself up by eating comfort food you can indulge yourself with painting subjects that dispel gloom. Look out for sunny celandines and coltsfoot, gilded catkins and fountains of forsythia. All year round there are bright bouquets and bunches of flowers on sale at the florist and supermarket. Trays of winter pansies and polyanthus are also cheerful subjects for late winter – their happy open faces will soon help you beat the blues. Luxuriate indoors and set up still lifes with your colourful flowers.

▽ **China and Blossom**

25 x 33 cm (9³/₄ x 13 in)

Looking for pots to suit your flowers is part of the fun of indoor work and gives you a chance to experiment with containers of varied sizes, shapes and materials. The background you choose to paint behind the subject will dramatically affect its impact.

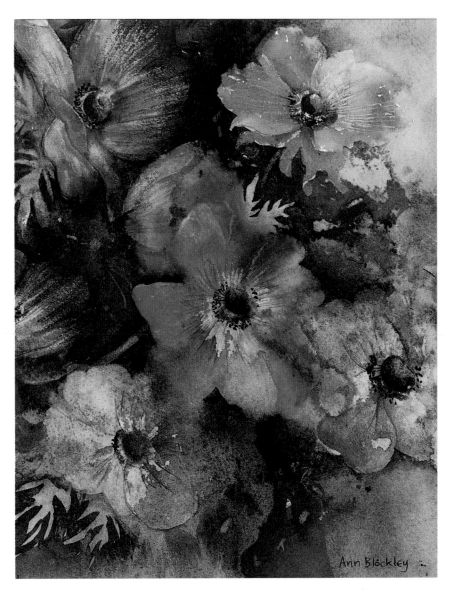

◁ **Anemones**

29 x 20.5 cm (11¹⁄₂ x 8 in)
Anemones are a happy subject for February, and they can be found in most florists. I enjoy painting their cheerful faces, bright colours and expressive shapes over and over again. Each time I look for new patterns, paint marks and backgrounds suggested by the flowers.

Working indoors

There are enormous practical advantages to working indoors. It is comfortable, all your materials are close at hand and there is a plentiful water supply. You can spend time and spread out, experimenting with techniques and compositions, and there is the option to work from sketches, photographs, imagination or real life subjects, or indeed any combination of such reference materials.

There are few flowers to pick in February, which makes the ones you do have even more precious. Many subjects will be quite small and dainty, for example pussy willow, periwinkle or a late snowdrop. These can be painted in little containers such as a small ink pot, a sherry glass, a tiny jug or an empty perfume bottle.

Working indoors gives you the luxury of maintaining a constant light source which can be angled to illuminate your subject to its best advantage. A strong light can help to simplify flowers, and it is also easier to describe the three-dimensional form of a side-lit container as its surfaces turn from light to dark.

Building up flowers

In a floral painting it is generally best to start pale and gradually add darker layers, taking care to let the colours dry between each stage in order to retain the crisp freshness that is the hallmark of traditional watercolour. Occasionally, however, in the case of a richly coloured flower or a particular mood I want for the painting I use dark, thick paint to begin with and lift out paler areas with a damp brush or scrape out with the side of a scalpel.

Shading paint in a small area is rather like laying a miniature graded wash. When petals have different colours within them the technique is to paint them as if one colour grows out of the next, not as separate units. This can be done by using variegated washes that blend from one pigment into another or by painting a second colour wet-into-wet on top of the first overall wash, which will give a natural-looking flower. My method is to brush a band of colour with the darkest paint then wash my brush in clean water, blotting off the excess onto a paper towel. I immediately continue to brush the dark band of paint further across the area, repeating the process until it fades away without leaving a hard edge.

▽ **Winter Pansies**
19 x 24 cm (7 ½ x 9 ½ in)
Winter pansies combine the rich, strong colours that we need to cheer ourselves up at this time of year. Flashes of yellow golds are a contrast to the wide range of dark purples. Here I have used several pigments to achieve maximum variety. They include Purple Madder, Permanent Magenta and Thionindigo Violet as well as combinations of blues such as French Ultramarine or Phthalo Blue with a warm red such as Alizarin Crimson.

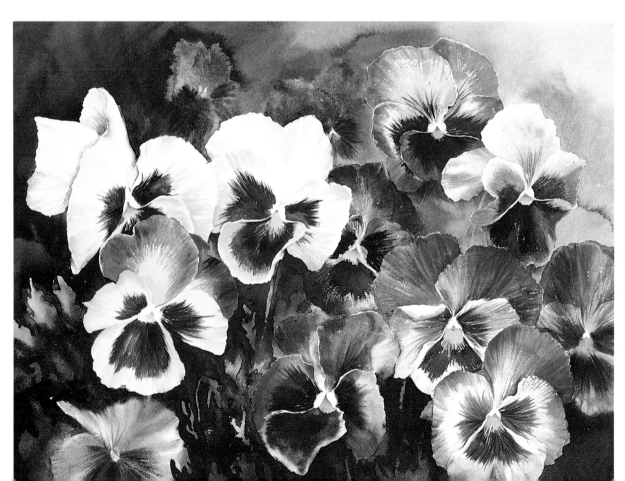

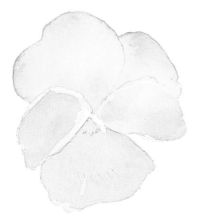

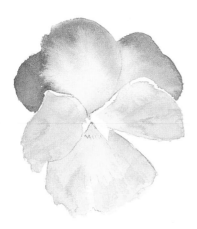

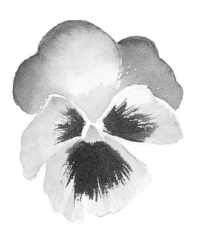

project . . . Flower centres

✦ You can bring your flowers to life by adding detail to the centres. Practise different types of centres, making them belong to the flower - they should not look like separate elements.

✦ Establish centres with a soft wash, defining further when it is dry. Keep some soft edges and crispen others to give lift.

✦ Try masking out pale stamens. Put in dark centres with stippled brush marks. Make sure your centre is the correct tonal value in relation to the rest of the flower.

◁ Establish a coloured centre by dropping yellow on top of a solid pink flower to create a soft shape. Paint the 'hole' in the centre by darkening the lower edge and leaving the top edge alone. Define the yellow star shape with pink paint.

▷ Establish the colours with a wet-into-wet wash. Create the effect of the raised centre or 'eye' by darkening the near edge and giving this the most detail.

△ To paint these variegated petals a wash of Indian Yellow was first painted over the whole flower, leaving a few white highlights where the petals overlapped. While this was still damp, Purple Madder was drifted into the petals. When the first washes were dry the pansies' dark markings were added using dryish paint and feathering it at the edge with a fanned-out brush. A further layer of stronger paint was added, and a final dark touch was smudged into the centre to bring it to life.

◁ Mask out stamens and paint a wash over them, adding a darker tone to the middle. Remove the mask and fill with a wash of yellow. Darken it at the centre to make the stamens grow out of the flower.

demonstration . . . Anemones

I expressed the cheerful exuberance of these brightly coloured anemones through a quick, spontaneous painting. I deliberately retained plenty of white background in order to emphasize their light, bright, airy quality.

COLOURS

Alizarin Crimson
Cadmium Red Deep
French Ultramarine
Green Gold
Indanthrene Blue
Indian Yellow
Purple Madder

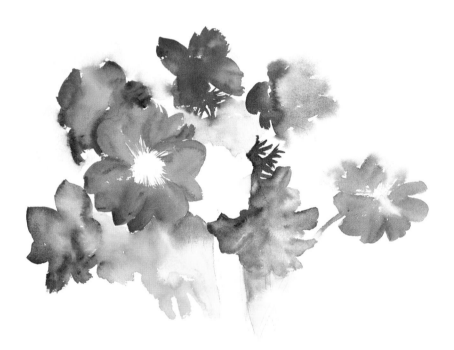

◁ **Stage 1**
After arranging the anemones to face in various directions, some overlapping and others separated, I made a pencil drawing. Then, working from left to right, I established the colours of the different flowers, linking them as I progressed with areas of background which I dampened in places to make soft edges. Where the flowers had pale centres I feathered the paint in towards the middle.

▷ **Stage 2**
Using darker paint I added tonal patterns to the flowers, dampening in places to lift or scrape off colour where I wanted paler marks. I washed in mauve colour over the white centre of the red flower and also into the white flower, leaving plenty of paper showing at the petal edges. I then used more leaves to define the shapes of some of the anemones.

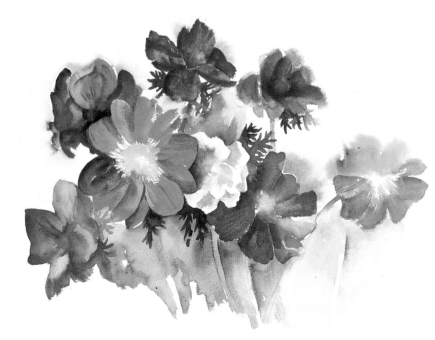

118

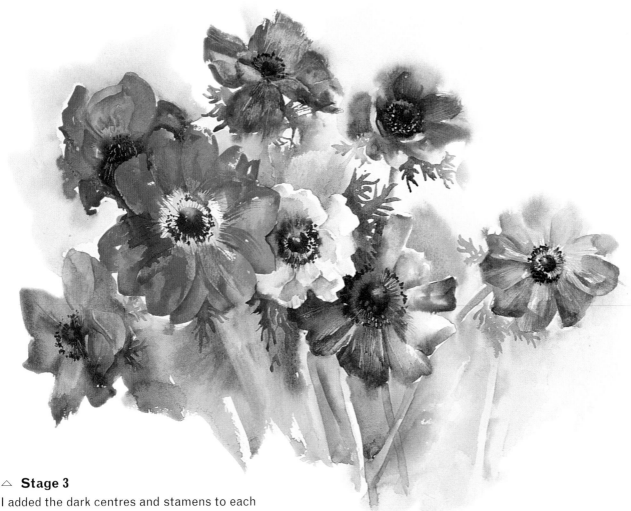

△ **Anemones** *38 x 47 cm (15 x 18¹/₂ in)*

△ Stage 3

I added the dark centres and stamens to each flower, using Indanthrene Blue toned down with a purple. The circular 'eyes' were painted first, blotting out highlights to give them extra life. I flicked out the stamens with a fine brush, adding the surrounding dots last of all. With these dark tones in I could now assess how much more work to do on the flowers and strengthen them until I was satisfied with the balance of detail and tone.

FURTHER IDEAS

Choose two or three specimens of the same flowers but this time close-frame the composition so that some of the petals reach right out of the edges of the picture. There should be very little background, but make sure that these areas as well as the actual flowers make interesting shapes.

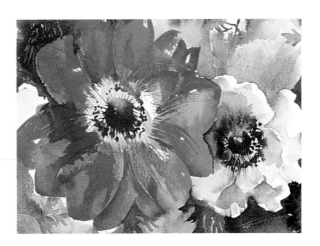

△ Detail from **Anemones**

119

Glossary of Techniques

Basic wash ▷

This is the key method for watercolour painting. Dilute plenty of pigment to a milky consistency and use a large brush. Tilt the paper to help the paint flow and slightly overlap each brushstroke. The colour should blend itself without further brushwork. Paint in any direction but do not rework areas. Reload your brush as needed. If covering a large area you could choose to dampen the paper first. If working round a shape dampen only up to its edge.

◁ Graded wash

Lay the paint in a similar way to the basic wash. This time, when you need to reload with paint, clean your brush instead using fresh water and continue as before. The paint will blend itself into the damp surface, becoming paler. Repeat the process until the colour has completely faded into the white of the paper.

Variegated wash ▷

Colours in nature are rarely uniform. A variegated wash is useful as it shifts from one colour to another. It is vital to have all your colours prepared before you start and to work quickly. Lay different washes of colour in a random direction. Let them meet and blend on the tilted surface of their own accord without overworking. Do not be tempted to work back into a wash you are not satisfied with. To aid blending in a large area you could try working on damp paper.

Wet-into-wet ▷

Lay a wash of paint either in a background or shape and add another colour into it. You can either drip the new colour in or lightly touch it in with a loaded brush. The paint will merge softly. How far it spreads will depend on its degree of wetness. You can, for example, use this method for patterns, shading, establishing flower centres or background shapes.

◁ Wet on dry

To build up layers of colour for shading and adding depth, you need to work wet on dry. Your first wash must be bone dry before another wash or shape is laid on top. You can add positive shapes or paint between in the negative spaces as shown.

Backruns ▷

Backruns occur when wet paint is brushed into a damp or drying wash. The new paint seeps into the dryer pigment, pushing it into a jagged-edged mark. To avoid this happening, any paint applied next to or on top of a wash that is not dry should be of equal liquidity. Any attempt to blend in an accidental backrun will make it worse, and it is better to leave it or adapt it into a feature of the painting. You can create backruns on purpose to build up marbled textures or the suggestions of irregular background leaves, flower centres or petal shapes.

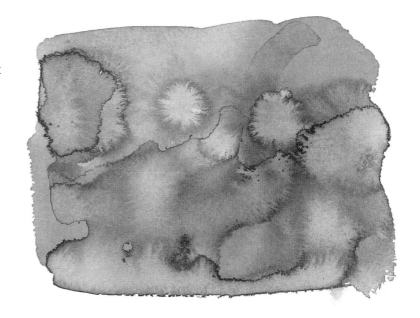

techniques

Washing out ▷

In this technique the most dramatic results occur when the paint is quite strong. Apply a wash over a background or into shapes. Leave it until some parts are dry and others are still damp. Take a jug of clean water, tilt the paper over a bowl or sink and direct a controlled flow of water on to the damp sections of the picture. The moist paint will wash away, leaving the dry pigment still staining the paper. The more water you pour the more paint will disappear, so do this tentatively, one step at a time, until you achieve the result you want. This technique can be a little risky and unpredictable but can also create wonderful blotchy textures. Experiment before trying it out on a promising painting.

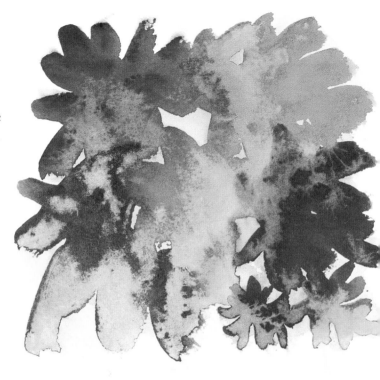

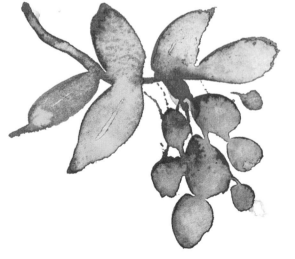

◁ **Dropping in water**

Paint a shape with a wash of pigment, not too dilute, and as it begins to dry, drip water into the centre. As it dries the water shifts the paint into wonderful gradations and textures, often with a delicate outline around the edge.

▽ **Broken paint**

Not all areas need to be smoothly blended. By using your brush in different ways you can vary the effects. Dragging paint with the side of a brush and skating over the rough surface of the paper achieves a broken texture. Lift the brush off and reapply it to build up a pattern of marks. Working on dry paper results in the coarsest textures.

Blotting ▷

Blotting paint out of a damp wash is an extension of the lifting out method (see below). Here it is used as a texture-making device. Use an absorbent material such as paper towel and press it into damp paint, disturbing and blotting out some of the pigment. Repeat until the required effect is achieved. If the material is crumpled or textured a more random finish will result.

◁ Sponging

Sponging paint on is the opposite method to blotting out. Use a sponge or crumpled tissue to dab paint on to dry paper or a dry wash, building up mottled textures. You can vary the paint's consistency and the pressure applied to create a light or dense effect.

▽ Lifting out

Paint can be lifted out of a wash to achieve highlights or pale areas. If the wash is still damp you can absorb the paint with an almost-dry brush. If it is dry you will need to use a damp brush and gently stroke away the unwanted paint, carefully blotting with tissue. A cotton bud is useful for lifting out a small area.

Scraping ▷

Use the edge or tip of a flat scalpel blade, small slice of plastic or even cardboard to scrape paint out of a wash. This works best when the paint is just damp or if the pigment is quite thickly applied. You can try different sizes and shapes of tool to make other marks and vary the movement to indicate a variety of subjects. If the wash is completely dry you can use a sharp blade to flick or scrape off patches or lines of pigment back to the white paper.

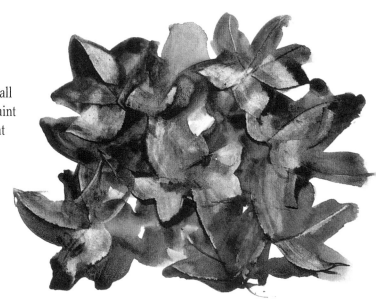

◁ Scratching

Use a sharp point such as a scalpel tip to delicately score lines through damp paint. Where the paper surface is scratched the paint will settle to form darker lines. You can also scratch paint out of a shape, extending the damp pigment into fine lines. This time you are lightly dragging paint across the surface rather than scoring it.

▽ Spattering

Spatter creamy paint by running your finger over the bristles of an old toothbrush or flicking the tip of a palette knife. Spray onto wet paint for a soft texture and dry paint for a harder, speckled effect. Cover any areas you wish to preserve with scraps of paper, being careful not to disturb any wet washes.

Salt ▷

Sprinkle salt into a wash to create a mottled texture. The salt absorbs the surrounding paint to make pale snowflake markings. The effect varies according to the spacing of the crystals and wetness of the paint: large rock salt crystals make bigger, more dramatic shapes than table salt and a damp wash leads to a subtler texture than a wet one. Leave the salt then brush it off when the paint is dry.

◁ Detergent

Mixing dilute paint with washing up liquid or liquid soap makes watercolour lose some of its fluidity. Brush marks are retained to create movement and texture. The paint also froths and as the bubbles pop they leave rings and blobs within a wash.

▽ Masking fluid

The use of masking fluid allows you to paint freely over an area while still preserving white paper (see pages 28-9). Apply it thickly with a rubber shaper or brush. Draw lines and dots with a pen and nib or spatter fine dots with a toothbrush or palette knife. When it is bone dry it should peel away easily without rubbing. Any tenacious bits can be eased off gently with a putty eraser.

Materials

Brushes ▷

Four sizes of pointed brush should be sufficient for basic watercolour techniques. I use sizes such as 20, 12, 7 and 2, depending on the wash area or degree of detail. Sable or sable blends give excellent results. To try out more varied styles of brushwork you will require different shapes of brush such as flat-ended, rigger or squirrel mop.

◁ Paper

Most of the finished watercolours in this book were painted on 300 gsm (140 lb) Waterford Not paper, which has a surface that allows a combination of paint flow and detail. Rough and smooth (HP) papers are useful if you want to vary the texture of your brushwork. Keep to white paper to maximize the translucency of your watercolour. I feel that tinted papers should be reserved for sketches and experiments. Loose sheets of paper are more versatile than small pads as you can cut them into a greater variety of sizes and formats. I find the offcuts invaluable for trying out colours before starting work on a painting.

Colours ▷

Pans of paint are fine for sketches and details but plenty of freshly squeezed moist pigment from a tube is vital for my techniques. I use a basic palette and introduce 'guest' colours to vary the atmosphere or to match specific flowers.

A basic palette includes a mixture of browns and a range of cool and warm blues, reds and yellows such as French Ultramarine, Alizarin Crimson, Cadmium Red, Cadmium Yellow, Indian Yellow, Burnt Umber and Burnt Sienna. 'Guest' colours in this book include Quinacridone Gold, Yellow Ochre, Green Gold, Sap Green, Transparent Red Brown, Warm Sepia, Phthalo Blue, Perylene Maroon, Purple Madder, Thionindigo Violet, Purple Magenta, Permanent Rose and Cadmium Red Deep.

Inks ▷

I use transparent acrylic artist's inks for vivid colour. These are lightfast and water-resistant. My palette choice is listed on page 88.

◁ Extras

My favourite palettes are large white plastic ones with small spaces for squeezing paint and large reservoirs for mixing. Waterpots must be sturdy and as big as possible. Plentiful supplies of fresh, clean water are absolutely essential. Some form of support for the paper will be required; I use a plywood board, preferably in different sizes to suit the picture format. You will also need a B pencil and a soft eraser for your initial drawing.

Masking fluid and texture-making items ▷

Masking fluid is a latex solution that can be applied to any area of paper you wish to preserve. I prefer the tinted to the colourless variety. You will need a brush or shaper for basic applications. For texture-making techniques you can try anything you like! I have used salt, washing up liquid, Indian ink, a scalpel, a palette knife, a toothbrush, and cotton buds, sponges and paper towel for blotting and lifting colour.

◁ Sketching materials

Sketching is intensely personal and you should make your own choice of materials. These might include anything from a pencil and paper to some or all of the following: pen and ink, charcoal, coloured pencils, oil pastels, wax crayons, paints, felt tip pens and a variety of papers and pads in a size to suit you. A lightweight easel, folding canvas stool and collapsible water pot are useful on location and a camera is helpful for extra reference.

index

Page numbers in *italic* refer to captions